THE BEGINNER'S GUIDE TO
WHEEL THROWING

A Complete Course for the Potter's Wheel

JULIA CLAIRE WEBER

Inspiring | Educating | Creating | Entertaining

Brimming with creative inspiration, how-to projects, and useful information to enrich your everyday life, quarto.com is a favorite destination for those pursuing their interests and passions.

© 2021 Quarto Publishing Group USA Inc.
Text © 2021 Julia Weber
Photography © 2021 Quarto Publishing Group USA Inc.

First Published in 2021 by Quarry Books, an imprint of The Quarto Group,
100 Cummings Center, Suite 265-D, Beverly, MA 01915, USA.
T (978) 282-9590 F (978) 283-2742 Quarto.com

Quarry Books titles are also available at discount for retail, wholesale, promotional, and bulk purchase.
For details, contact the Special Sales Manager by email at specialsales@quarto.com or by mail at
The Quarto Group, Attn: Special Sales Manager, 100 Cummings Center, Suite 265-D, Beverly, MA 01915, USA.

10 9 8 7 6 5 4 3 2

ISBN: 978-1-63159-935-4

Digital edition published in 2021
eISBN: 978-1-63159-936-1

Library of Congress Cataloging-in-Publication Data

Names: Weber, Julia (Julia Claire), author.
Title: The beginner's guide to wheel throwing : a complete course for the
 potter's wheel / Julia Weber.
Description: Beverly, MA, USA : Quarto Knows, 2021. | Series: Essential
 ceramics skills | Includes bibliographical references and index.
Identifiers: LCCN 2021015830 (print) | LCCN 2021015831 (ebook) | ISBN
 9781631599354 (hardback) | ISBN 9781631599361 (ebook)
Subjects: LCSH: Pottery craft. | Pottery--Equipment and supplies.
Classification: LCC TT920 .W43 2021 (print) | LCC TT920 (ebook) | DDC
 738.1/2--dc23
LC record available at https://lccn.loc.gov/2021015830
LC ebook record available at https://lccn.loc.gov/2021015831

Design: Allison Meierding
Cover Image: Jack Sorokin Photography
Page Layout: Allison Meierding
Photography: Jack Sorokin Photography

Printed in China

△△△

To my daughter Olive. May you always have the courage
to follow your dreams, whatever they may be!

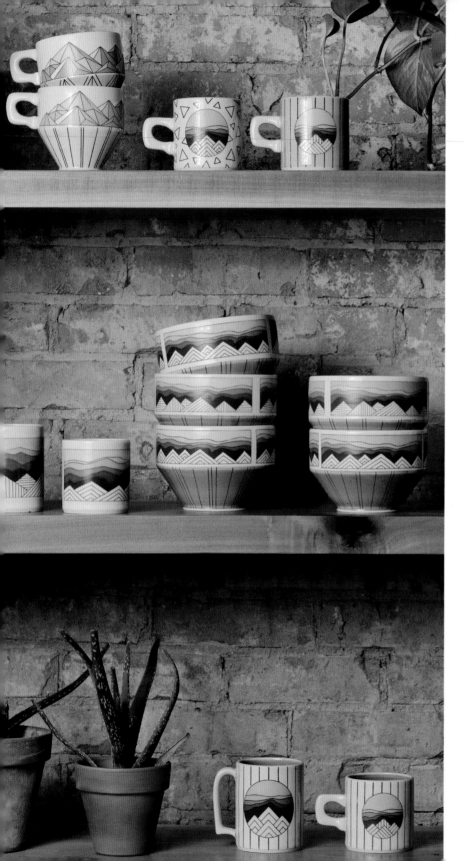

CONTENTS

FOREWORD

Since I began making pottery, I've always looked for more information and read every book about ceramics that I could get my hands on. I kept a notebook and sketched out ideas and artist names that inspired me. Over time, the idea of process has come front and center with my pottery. I'm interested in breaking down each step, high-lighting details, and expanding on simple and complex ideas throughout the making process—combining ideas like wheel throwing out of press molds, slab building textured cylinders, and using my everyday surroundings on the surface of my pots.

I met Julia in 2010 during my first year of under-grad studies at Edinboro University. She had recently graduated and was the current studio tech. Julia had an infectious personality, great craftsmanship, and endless positivity, making the studio a fun and exciting place to be. Her strong work ethic motivated me to push myself and my pottery further. Julia was always testing, working on new forms, and expanding on her ideas and processes. When Julia moved to Asheville, North Carolina, it seemed like all of the pieces fell into place for her—she strived as an artist, her pots becoming the story of her journey and where she was in that exact moment.

The Beginners Guide to Wheel Throwing is an effective tool for everyone. The information is broken down in a very clear way; Julia explains the tools and techniques needed to become a successful wheel thrower. She guides us through her processes with the same excitement she has as a maker, leaving the reader eager to learn more. She is generous in sharing her ideas and techniques and includes images of many talented artists, both emerging and established.

—Mark Arnold, studio potter

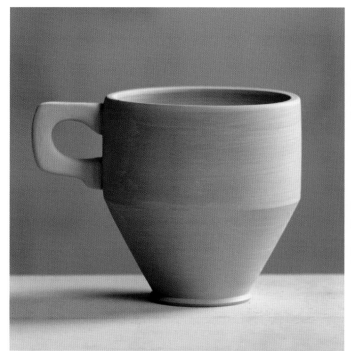

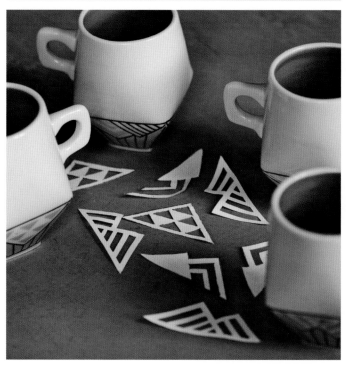

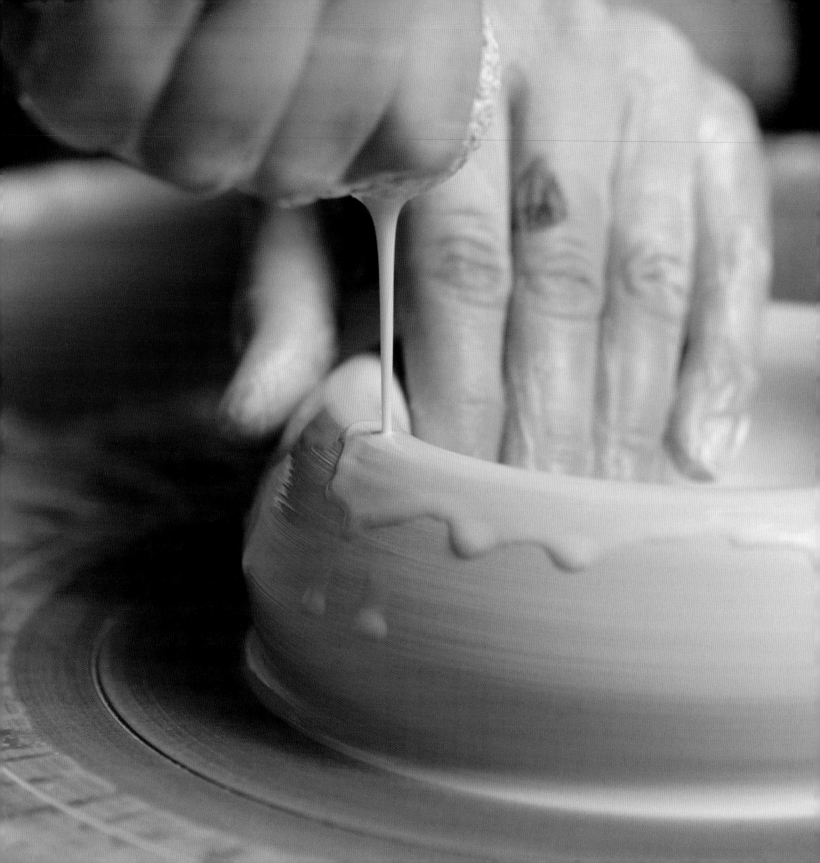

1
GETTING CENTERED IN THE STUDIO

When you have the itch to try pottery for the first time, it is only natural to want to jump right in and sit down at the wheel. This is great! Excitement is the key to success. While there is nothing better than natural motivation, there are some fundamentals that are helpful to learn. In this chapter, I will guide you through choosing the right type of clay and understanding the basic differences in each, as well as outlining the common tools and materials you will need. I encourage you to pay close attention to the studio safety suggestions so you develop healthy and safe habits right from the start. When flipping through this chapter, remember there are several choices you can make and many paths you can take. Safety aside, my goal is to help you find the best options and best practices *for you*. So, without further ado, let's get our hands dirty!

CLAY

Clay is made in nature through the physical and chemical weathering of rock. The theoretical formula of clay is $Al_2O_3\ 2SiO_2\ 2\ H_2O$, meaning it is made up of alumina, silica, and water. During Earth's molten stage, heavy materials sank and minerals rose. Over time, wind and water broke down igneous rock and clay was formed. This means clay can be found naturally. In certain areas, you can dig your own clay—though typically it needs to be processed before use. These days, most potters prefer to purchase already mixed clay through a clay distributer rather than mixing it themselves. When you shop, you will find there are different types of clay bodies for different types of uses, but they all start with the three basic ingredients: clay, filler, and flux. When deciding which clay to use, it is important to consider your options and the qualities each clay possesses.

Types of Clay

Earthenware is a low-fire clay. It is generally the least durable of the clays because it typically is not fired to a vitrificated state. Think flowerpot. The firing range is 1828 to 2124°F (cone 08 to 4). While it can be white or buff, red earthenware is the most common. Red earthenware contains a high iron content, causing the clay to fire to a rusty color. Earthenware is good for beginners as it is not likely to warp, accepts attachments well, and holds form when working with slabs. It has an absorption rate of 5 to 10 percent.

Stoneware clay is a midrange to high-fire clay. It is more durable because it is fired at higher temperatures, causing the clay to vitrify, hence the word "stone."

The firing range is 2167 to 2383°F (cone 5 to 12). Most stoneware clays are incredibly workable, making them appropriate for beginners. Choosing the right stoneware clay depends on your specific needs. It has an absorption rate of 1 to 5 percent.

Porcelain is a high-fire clay. It is the purest of the clays with a fine texture and is glassy and vitreous. Some but not all porcelains are translucent when the walls are thin enough. The firing range is 2232 to 2383°F (cone 6 to 12). Porcelain is the most fickle of the clays. It lends itself beautifully for throwing and trimming but has a fierce memory and a high shrinkage rate, which can cause warping and cracking. It is not recommended for beginners. It has an absorption rate of 0 to 2 percent.

Words to Know

What do **vitrification** and **absorption** mean? When a clay body is vitreous, it means that water cannot be absorbed into the clay when it is fired to its maturing temperature. Therefore, the absorption rate refers to the amount of water that can be absorbed into the clay after glaze firing, signifying its durability. Generally speaking, the higher the percentage, the lower the durability.

Plasticity is used to talk about general workability of clay. The more "plastic" a clay is, the more flexible it is. Plastic clay is generally easier to work with on the wheel as it is able to change shape easily without cracking. Freshly mixed clay is not as "plastic" as aged clay because the particles have not had adequate time to interlink. Think of puzzle pieces clicking together. To test your own clay's plasticity, roll a coil and bend it.

Cones are used in ceramics to define temperature ranges. Rather than saying, "I fire my clay to 2232 degrees Fahrenheit," you can say, "I fire my work to cone 6." Cones are also physical objects, cone-shaped pieces of clay formulated to melt at a specific temperature. Physical cones or "witness" cones are used in kilns to track and monitor temperature and to determine whether a kiln is firing evenly.

Low fire, midrange, and **high fire** are terms used to describe the temperature at which you glaze fire your pottery. Low fire is typically firing at a cone range of 06 to 1. Midrange is the process of firing at a cone range of 4 to 7, and high fire is typically cone 8 to 14.

Flux is a material used to lower the melting point in clay and glazes.

TOOLS AND MATERIALS

When it comes to working with clay, there's no denying your best tool is your hands. Nevertheless, there are *so many* cool clay tool options out there, all made specifically to help you have a higher success rate in making pottery! Let's go over the tools you are most likely to encounter in the studio.

The Wheel

When it comes to choosing a wheel, every potter has their own preference. To discover which wheel is best for you, I recommend taking a community clay class. Chances are the studio will have a few different brands/models, allowing you to peruse and see what you find most comfortable. Here are some tips to consider when looking for the perfect wheel for you.

› How much clay can the wheel handle? This will depend on motor speed and wheel head size. If you plan to work your way to large forms or to make a career out of pottery, you might want to consider going with a model that gives you that ability.

› Do you want the wheel to rotate in both directions? Most Western wheels spin counter-clockwise (the preferable direction for right-handed potters). If you are left-handed, you might want to try throwing clockwise. Not all wheels have this feature. Keep in mind that if you are spinning the wheel clockwise, you should reverse all hand positions for the techniques shared in this book, which are written from a right-handed perspective. That said, my personal preference is a wheel that spins both ways. For whatever reason, I am most comfortable painting underglaze with the wheel spinning clockwise.

› Is the wheel able to spin freely when the motor is off? Some wheels operate using a belt and some don't. Wheels without a belt are able to spin freely, like a banding wheel, making it easy to turn the wheel with your hands to an exact position. Wheels with belts provide tension, and hand turning them can decrease the motor life. Whether or not a wheel has a belt also determines how fast it stops when you stop the pedal. Wheels without belts stop immediately, while wheels with belts make a few extra rotations as they come to a stop.

Basic Wheel Tools

SPONGE – A sponge is typically used to moisten clay during the throwing process and is also useful for cleanup. I use a sponge as a buffer between my fingers during wheel throwing. I love my sponge!

WIRE CUTTER – The needle tool is used to remove your finished pot from the wheel and to slice clay before wedging.

WOOD KNIFE – This knife is used to remove excess clay at the foot of your pot at the end of the throwing process.

NEEDLE TOOL – The needle tool is used for many tasks but especially for slicing the rim of a pot on the wheel to make it even.

RIBS – There are several different kinds of ribs, including wooden, metal, and plastic. They are typically used in the throwing process to smooth clay and to refine the shape, but they can also be used during the decorating and finishing process.

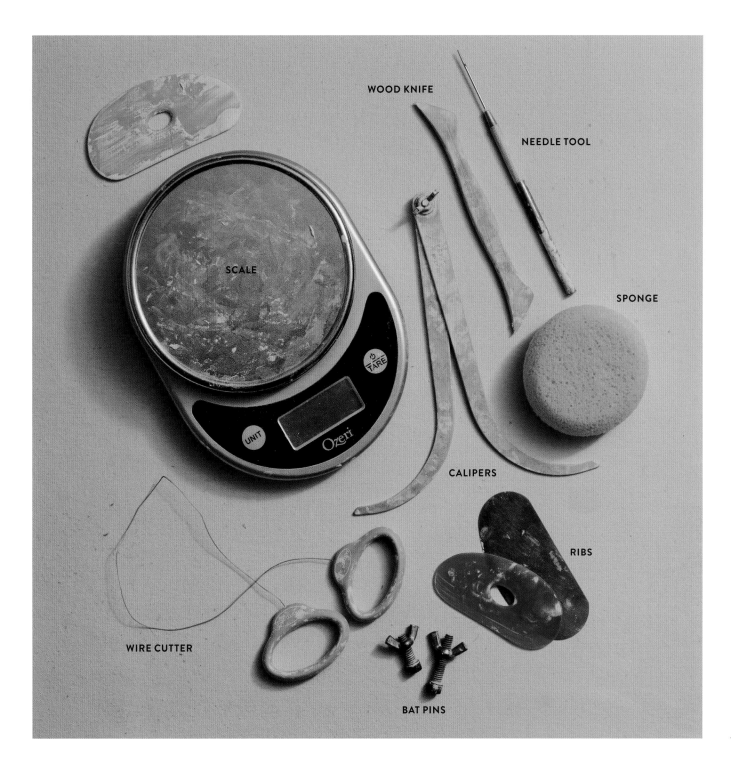

WOOD KNIFE

NEEDLE TOOL

SCALE

SPONGE

CALIPERS

RIBS

WIRE CUTTER

BAT PINS

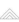

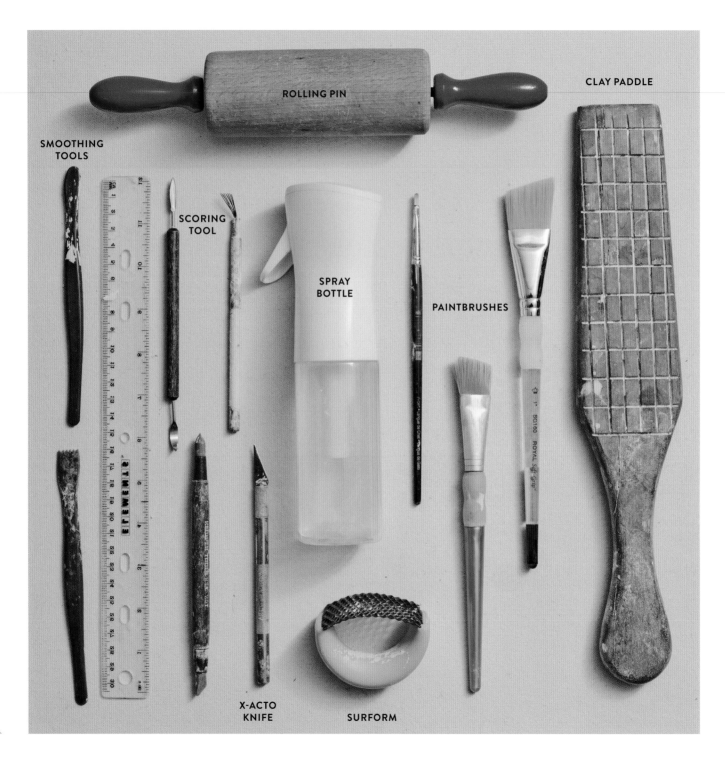

ROLLING PIN

CLAY PADDLE

SMOOTHING
TOOLS

SCORING
TOOL

SPRAY
BOTTLE

PAINTBRUSHES

X-ACTO
KNIFE

SURFORM

CALIPERS – Calipers measure diameter when throwing forms such as jars and lids. Lidded forms are beyond the scope of this book, but you might also use calipers to measure pots when making a matching set.

SCALE – When weighing clay, a scale is essential for mixing slip or glaze.

BUCKET – I use a bucket to hold water while throwing, but buckets have a million other uses around the studio.

BATS – Bats are flat disks or square attachments that are secured to the wheel. They are used so pots can be easily removed from the wheel without having to directly touch them. They make life easier when throwing flat or large objects on the wheel.

BAT PINS – Bat pins secure the bats on the wheel.

POT LIFTERS – These help you lift your pot off the wheel with ease.

WARE BOARDS – Ware boards are used for carrying multiple pots much like a waitress carries a serving tray. Potters typically use wood or other materials, but I prefer drywall because it absorbs some of the moisture of the pot without sticking. Just be sure to duct tape the edges of drywall boards so they don't crumble or deteriorate.

Trimming Tools

LOOP TOOLS – Coming in all shapes and sizes, these tools are used to trim excess clay off pots. Different shapes make different impressions.

TURN TOOLS – This style of trim tool uses an elongated L-shaped edge to trim a larger surface area. Turn tools are also used to create a textured chattering effect.

SPRAY BOTTLE – A great tool for keeping pots moist.

RESPIRATOR – Respirators protect your lungs from clay dust and toxic materials. These are not just for mixing glazes; you should wear a respirator when cleaning any ceramic studio or wherever dust is present, such as when using sandpaper or similar tools on greenware.

Finishing Tools

X-ACTO KNIFE – I love my X-ACTO knife for a number of reasons. It is perfect for cutting handles, cutting slabs of clay, darting, and decorating.

SURFORM – Similar to a cheese grater, this tool is preferred for removing excess clay by hand.

SMOOTHING TOOLS – To get into all the nooks and crannies, smoothing tools are your friend when attaching pieces such as handles.

SCORING TOOL – Slip and score, scratch and attach. This tool is all you need (besides water) to merge together two pieces of clay.

PAINTBRUSHES – Having good brushes is key. Slip and underglaze will go on more smoothly during the decorating process with the help of a good soft brush.

ROLLING PIN – Extremely useful for flattening clay evenly and many other tasks. The more handbuilding or slab work you do, the more you will use a rolling pin.

BANDING WHEEL – A banding wheel is basically a turntable that allows you to spin the pot without picking it up. It is incredibly useful for decorating, sculpting, carving, and adding attachments.

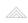

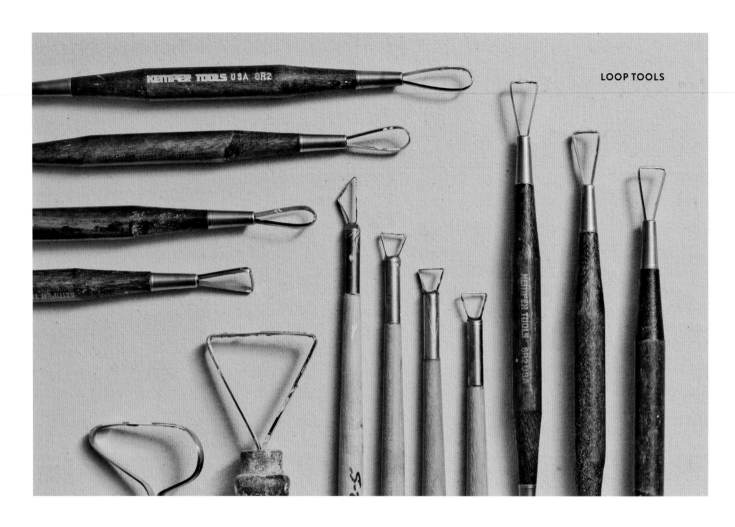

Decorating and Design Tools

DECORATING DISKS – These are used to map out equal parts of a pot and are great aids in executing calculated decoration (and altering) of pots.

SCISSORS – For cutting out transfers and designs; see chapter 5.

TRANSPARENCY PAPER – For mapping out decal designs; see chapter 5.

MICRON PENS – For designing decals; see chapter 5.

PENCIL AND PAPER – The classics, good for so many aspects of pottery planning.

STUDIO SAFETY

Whether or not you plan to make clay your career, it is best to practice studio safety from the beginning so you do not fall into any bad habits.

If you have long hair, tie it back and secure it. (I have sliced the top of a beautifully tall vase with a single strand of my hair, and even worse got my braid sucked into a standing glaze mixer—yikes!)

I recommend wearing comfortable clothing. Sleeves that can be rolled up easily and pants with some stretch or space will allow you to focus on what's happening on the wheel. You should also remove large rings, anything around your wrist, and dangling necklaces that could get damaged by clay or get in your way.

Do your best to avoid wiping wet clay hands on your clothes. The clay will dry and flake dust into the air. This is a habit I have worked so hard to break. Avoiding this is as simple as rinsing your hands in a water bucket or wiping them on an apron before wiping them on clothing.

Cleaning

Clay in its wet form is safe in that it does not release dust into the air. Once it dries, you run the risk of inhaling silica dust. This poses a health risk for career potters and ceramic artists because inhalation of silica dust over time can cause silicosis. Often referred to as "white lung," this condition causes emphysema-like symptoms. I share this not to scare you but to inspire you to develop good cleaning habits from the start.

Never sweep dried clay or glaze. Doing so releases silica dust and particles into the air, where it then settles on objects. Instead, use wet cleaning methods, such as a wet sponge or a wet mop. Better yet, get in the habit of disposing clay scraps before they dry. Also, every time you think you will have potential exposure to silica dust (whether it is cleaning dried clay, sanding greenware, mixing glazes, etc.), wear a safety mask or respirator.

While silica is the most common danger in the studio for potters, there are other materials to look out for. Always read labels before handling clay or dry materials. When you are mixing glazes with toxic materials such as chrome, manganese, copper, and vanadium, always handle and store these safely, use gloves, and wear a respirator. If you are unsure what is in the glaze you are using, treat it as if it contains ingredients like these.

No matter what studio you work in, don't eat, drink with an open container, or store food in a place where there could be any cross-contamination. Always wash your hands after working in the studio and before eating.

WEDGING CLAY

Once you have decided on the type of clay you are going to use, it's time to get your hands dirty. Preparing your clay well leads to successful throwing, which builds self-confidence. To prepare your clay for throwing on the wheel, you should first wedge it to an even and smooth consistency. Though some might say prepackaged clay does not need to be wedged, I still recommend it. Who knows how long the clay has been sitting in the bag? The outer layer may be a bit stiffer than the interior, so through wedging, you can shock the molecules into working together again.

The act of wedging clay can be compared to kneading dough but with a different goal: you will work the clay to ensure there are no pockets of air left inside. You may have heard the old scare tactic that air bubbles in clay cause pots to explode in firing. While these are not those air bubbles, what bothers me about them is that they can show up while you are throwing and potentially ruin an otherwise nice pot. So, wedge with intent.

TOOLS AND MATERIALS

wire cutter
scale
wedging surface
clay

NOTE *Using a wire tool, slice out the amount of clay necessary to throw a form. To get started, I recommend using 1.5 to 2 pounds (680 to 907 g) of clay. This will be enough to make a large cup or a medium-size bowl. I will dive deeper into specific clay weight for different forms in chapter 2.*

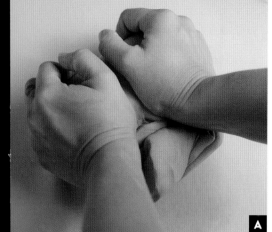
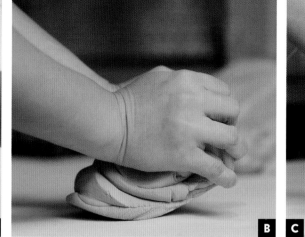
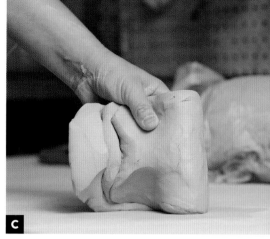

Basic Wedging

STEP 1 To make it easier on yourself, pound your clay into a loose ball. Next, drive the clay downward into the wedging surface at a 45-degree angle using the palm of your hands and holding onto the clay with your fingertips. **[A]**

STEP 2 Swoop your hands upward, still holding onto the clay at your fingertips, and repeat that driving motion. **[B]** Be careful not to make such drastic movements that you are flattening and folding the clay. This will add air to it rather than remove it.

STEP 3 To keep the clay from elongating continuously, pat the sides between each couple of rolls. At any time, you can lift up the clay and move it back to the center of the wedging surface to prevent it from traveling. **[C]**

TIP *As a beginner, you might find it difficult to tell whether you are wedging correctly or have wedged the clay enough. A quick way to find out is by slicing your clay in half with a wire cutter. If you spot any air bubbles, you should continue wedging, making sure you are following the above instructions by de-airing the clay. Either way, slap your two pieces back together and repeat the movements in steps 1 to 3.* **[D]**

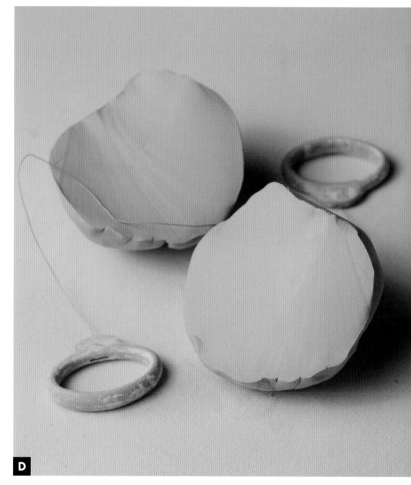

Spiral Wedging

Spiral wedging is another method. It is essentially the same process, yet this method tends to be a bit trickier and may take time to understand the motions. The basic difference is that you press more forcefully with one hand and the clay revolves in a circular motion, creating a spiral shell shape. In the photos, I use my right hand.

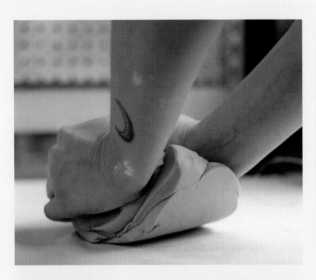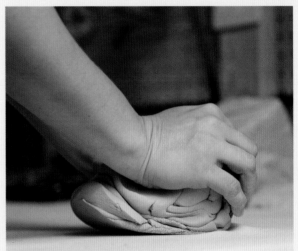

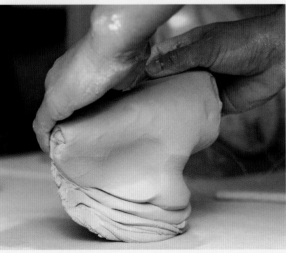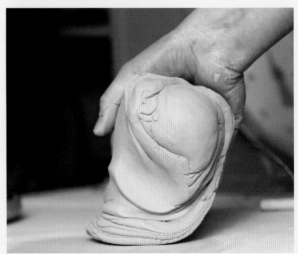

HOW TO MAKE A POT

The art of making pottery is a sweet metaphor for life. Centering clay may at first feel like a struggle, but if you alter your perspective, you might find the process is more deeply rooted than technique. Whether you use clay to stay centered in the midst of chaos or believe that the centeredness of your life directly relates to your ability to center on the wheel, one thing is certain—there is a spiritual connection to creativity! So take a deep breath, be open to learning, and let's get centered.

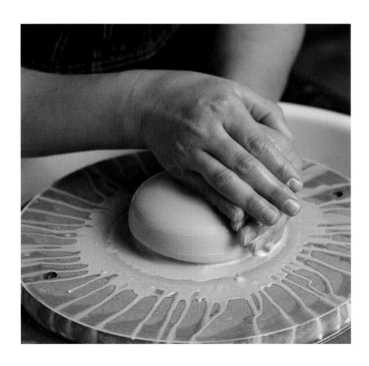

Centering

Before throwing the clay on the wheel, I recommended giving the wheel a test-drive. Turn the wheel on and put the pedal to the metal! Now slow it all the way down by easing up on the pedal. Getting comfortable controlling the wheel speed and transitioning speeds gracefully will make all the difference as you get going.

Maintaining Good Posture

It's important to practice good posture right from the start. When sitting down at the wheel, you want to sit as close to the wheel as possible with your hips and legs aligned evenly. I recommend raising the wheel on bricks or choosing an adjustable seat that lowers so your navel is just below the line of the wheel. This will prevent strain on your back and neck, allowing you to use your whole-body strength rather than just your arms. There is also the option to change your wheel to a standing position using cinder blocks or a table or legs made specifically for this purpose. Either way, I recommend taking time to find your comfort level so you develop healthy ergonomics.

TOOLS AND MATERIALS

bucket of water
sponge
1.5 lbs. (680 g) of clay, formed into a ball
wood knife

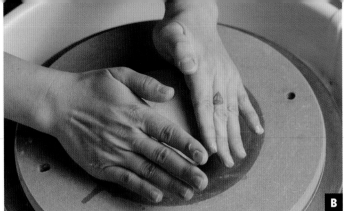

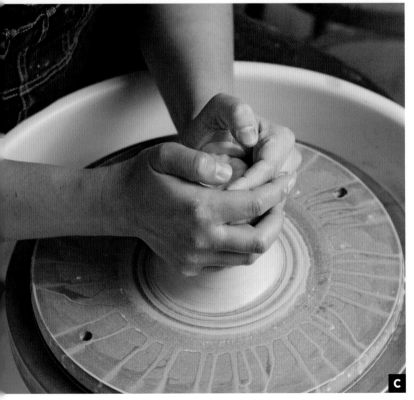

STEP 1 Throw your ball of clay as close to the center of the wheel as possible. If it's slightly off, there's no shame in pushing the clay closer to center. **[A]**

STEP 2 With your wheel spinning as slowly as possible, slap or pat the clay evenly with both hands, using your palms in a downward, inward motion. **[B]** If you forget this step, your clay may fly off the wheel mid-centering.

STEP 3 Coning up: Using your sponge, add water to the clay and begin spinning the wheel at a medium speed. Come in with both hands, one on each side of the clay, and let your palms connect to the clay. Place your left palm at 9 o'clock and your right palm at 3 o'clock. As the wheel is spinning and as if your hands were magnets reaching for each other, push inward while raising your hands up. What you are looking for is a nice, gradual cone shape. **[C]**

TIP *Use the right amount of force and aim to apply equal force with both hands. If one hand is working harder than the other, you will end up with a spiralized shape rather than a cone. If you push too hard with even pressure, you might chop the clay in half. If you don't push hard enough, nothing will happen. The key to mastering "coning up" (and really all wheel throwing techniques) is practice. Understanding when wheel speed is in harmony with movement speed takes time.*

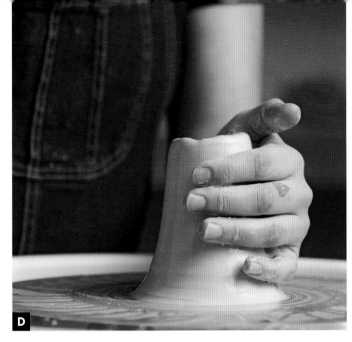

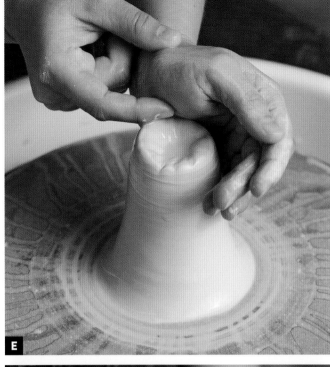

STEP 4 Coning down: Keep spinning the wheel at medium speed and bring your hands up to the top of the cone. Position your left hand as if you were shaking the clay's hand, with your palm between 8 o'clock and 9 o'clock. **[D]** Your right hand goes on top of the clay using the thicker part of your palm towards the pinky. **[E]** Push down with your right hand and push toward the center with your left hand. **[F]**

TIP *My aha moment in mastering centering came from this tip: If you're right-handed, focus on keeping your left hand steady. You can center almost entirely with one hand if you put your mind to it. Don't let the clay boss you around. Also helpful: Keep your elbows close to your waist. This will help you create a full body movement and prevent strain on your arms.*

STEP 5 Repeat steps 3 and 4 until you end up with a centered mound of clay. It is centered when the clay flows evenly and smoothly through your hands. If you were to cut the mound in half, both sides should be perfectly equal. **[F]**

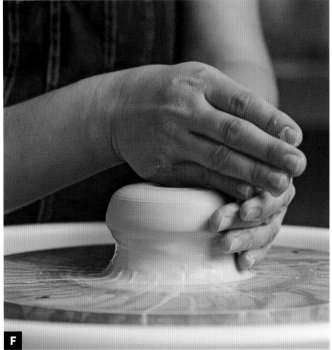

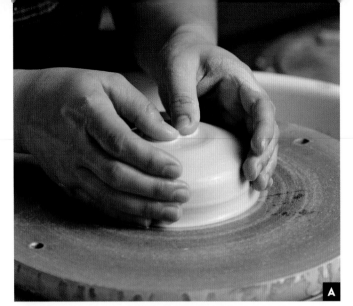

Opening the Clay

Now that you have a centered mound of clay, it is time to form the inside of your future pot. The movement of these next steps often depends on the form you are making. For instance, when throwing a bowl, you will most likely want a rounded inside. I will expand more on this later in chapter 2. For the sake of mastering the basics, a cylinder is a great starting point and the fastest gateway to throwing a mug.

STEP 1 While the wheel is spinning, cup both hands evenly around the clay. Make sure the centered mound of clay is moist so that your hands are smoothly gliding and not sticking at all. Bring both thumbs together so they are parallel. When teaching kids, I refer to this as the butterfly method, although it works perfectly as a visual for adults as well. **[A]** Find the center with your thumbs and start pressing down with even pressure. As soon as you feel your clay getting dry or at any sign of resistance, lift your hands gently off the clay and add more water.

STEP 2, OPTION A With the wheel spinning, continue using your parallel thumbs to push down toward the center until you are about ½" (1.27 cm) away from the wheel head. **[B]**

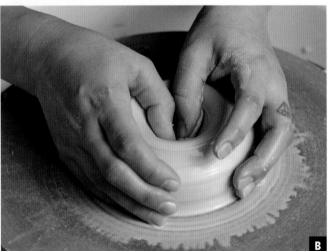

STEP 2, OPTION B Over the years, I have found that I have the most luck when positioning my hands a little differently from most potters. So, if the parallel thumb method doesn't seem to work for you, try this: using both hands as one, start this step with your right hand overtop your left hand, holding the sponge in between with your right hand thumb and pointer/middle fingers. With the wheel spinning, begin pushing your fingers down with even pressure toward the center. Stop when you have about ½" (1.27 cm) of clay between your fingers and the wheel. **[C]**

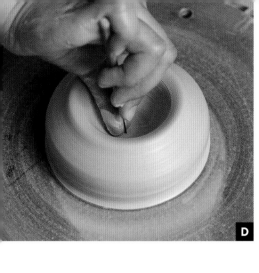
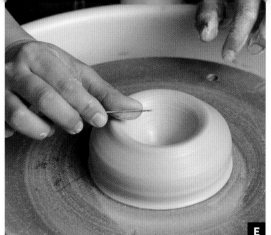
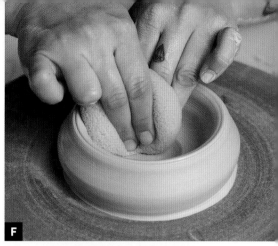

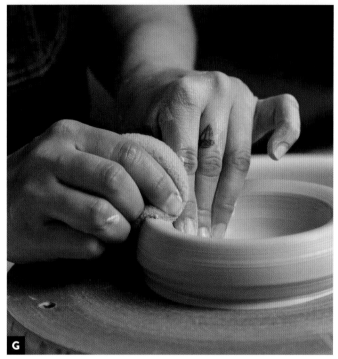

TIP *Sometimes visualizing depth can be difficult. To see how much space you have left, I recommend using your needle tool as a guide. With the wheel at a standstill, sink your needle tool into the center of the clay and slide your thumb to touch the clay.* **[D]** *Gently pull the needle tool out, keeping your thumb on the tool. If the depth looks good, use light pressure with the wheel spinning to smooth over the needle tool mark. If you need to go down further by repeating step 2, the needle tool mark will disappear automatically.* **[E]**

STEP 3 Once you are happy with the depth you have achieved, you are ready to open the walls. For this next step, I use a moistened sponge rather than drenching the clay. With the wheel spinning, come back to the center of the base with your right hand overtop your left hand and your sponge between your right hand and the clay. Using light pressure on the base of the clay, start pulling your hands toward the right side of your body. **[F]**

TIP *Make sure your clay stays moist and that your hands are not moving faster than the wheel is spinning. It is common to get excited and move your hands very fast, but this could result in pushing your pot off center!*

STEP 4 With the wheel spinning and sponge moistened, compress the walls of your clay with your sponge. For this step, I pinch the walls of the clay with my left hand like a lobster claw while my right hand is compressing. **[G]** The movement of this step is to ensure that your pot stays centered and that you are not stressing the rim of your clay.

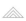

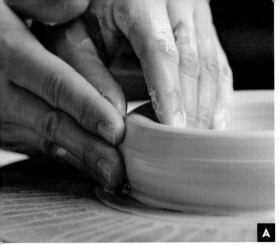
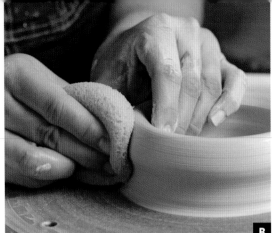
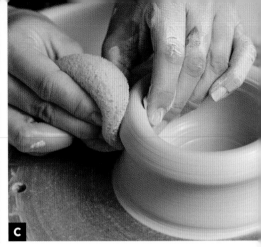

A

B C

Raising the Walls

Now it is time for the very exciting make or break moment. Don't be nervous; when you get this part right, it is very enjoyable. I will teach you how to successfully raise the walls of your cylinder.

STEP 1 Moisten your clay so it is slick but not soaking wet. I prefer to do this while the wheel is spinning so that the moisture will be even. Working on the right side of the pot, place your left hand on the inside and your right hand on the outside. With the wheel spinning at medium speed, gently push your fingers toward each other as if they were magnets, then start pulling upward using even pressure. **[A] [B]**

TIP *This is truly about even pressure, just like coning up. If you press too hard, like the strongest magnet connection, you might slice a donut of clay right off your pot. If you do not press hard enough, you might have a pot that keeps looking the same no matter how much you work on it.*

STEP 2 Once you reach the top of the pot and with the wheel spinning gently, compress the rim. Do this step after every pull, as it helps keep your pot centered and the rim a consistent thickness. You need to be gentle with your compression though. If you press too hard, you might erase the progress you made.

STEP 3 Repeat the pulling movement in step 1, only this time focus on the movement of your hands gliding straight upward. This might feel as if you are pulling up toward the center of the wheel. **[C]** The centrifugal force of the wheel spinning will make it feel natural for your hands to move outward when pulling the walls up. This is why many people teach starting with a bowl, but it's why I like starting with a cylinder. Being mindful of movement from the beginning gives you a pathway to success. **[D]**

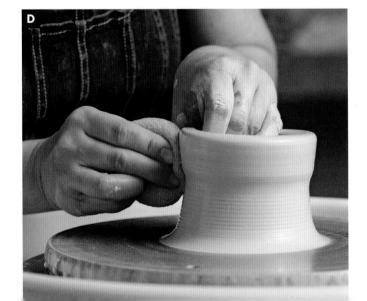

D

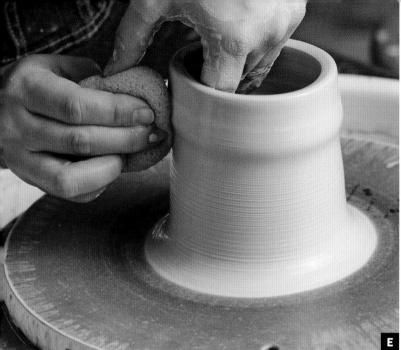

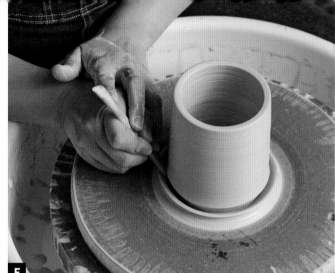

F

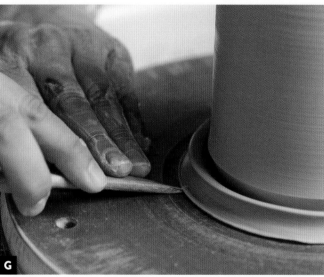

G

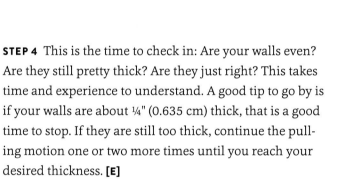

E

STEP 4 This is the time to check in: Are your walls even? Are they still pretty thick? Are they just right? This takes time and experience to understand. A good tip to go by is if your walls are about ¼" (0.635 cm) thick, that is a good time to stop. If they are still too thick, continue the pulling motion one or two more times until you reach your desired thickness. **[E]**

STEP 5 You might have noticed excess clay at the base of your pot. This is very common. To remove excess clay, use a wooden knife tool. While the wheel is spinning, hold the tool like a pencil and gradually slice through the clay at an angle until you reach the wheel head. **[F]** Next, hold the knife tool flush against the wheel, and while it is spinning, come underneath the clay until you reach your first mark. **[G]** Then remove the ring of clay. **[H]** This step takes practice, so if you don't get it on your first attempt, keep trying.

H

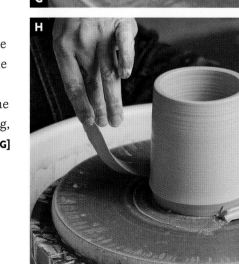

TAKING THE POT OFF THE WHEEL

Just as throwing the form takes gentle touch and patience, so does removing it from the wheel. There are several ways to successfully take your pot off the wheel. I will show you what works best for me and most of my students in this tutorial.

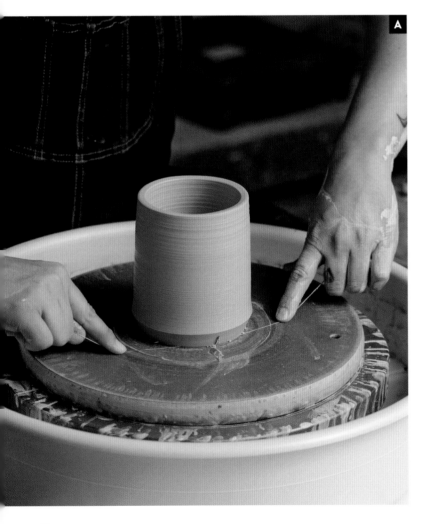

TOOLS AND MATERIALS

wire tool

pot lifter

sponge

ware board or other surface, ready for your pot

Instructions

STEP 1 Grab your wire tool and carefully place it behind your pot using your index fingers or thumbs to hold each side down. **[A]**

STEP 2 Slide your wire tool completely under your pot until you reach the other side, the front. Be careful not to lift your hands up until you have cleared the bottom of the pot.

TIP *If this is a practice pot and you want to see how even your walls are, stop halfway and pull the wire tool up through the middle of your pot.*

STEP 3 Add water behind the pot on the wheel head. Then slide your wire tool underneath again. Be mindful not to lift up too soon; those thumbs really help! The added moisture and second swipe will make it easier to take your pot off the wheel.

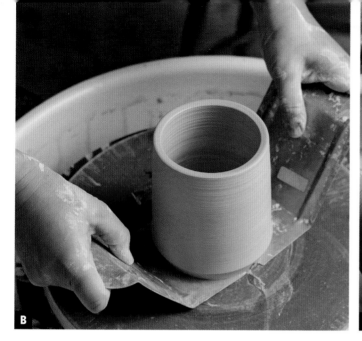

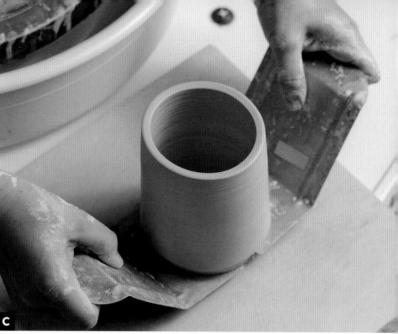

STEP 4 Grab your pot lifters, one in each hand, and like a spatula, scoop them underneath your pot. **[B]** With both hands, use even force and lift your pot off the wheel. Don't be afraid of this movement. If you gently rock the pot lifters back and forth, you should feel the pot wiggle a little before you lift up. Remember, this is about gently removing the pot off the wheel. Too much force could cause the pot to go flying across the room. **[C]**

TIP *Have your ware board or other surface ready and in an easy to access location before you lift your pot off the wheel. In almost every class, there will be a student taking a pot off the wheel with their pot lifters yelling "Help!" because they forgot they have to put that pot somewhere! It's funny, but it can definitely lead to disappointment if you drop your pot.*

STEP 5 Place your pot and pot lifters on your ware board. Gently press down and outward with your pot lifters and *voilà*. Your pot is ready for the drying process. For tips on successfully drying pots, skip ahead to page 70.

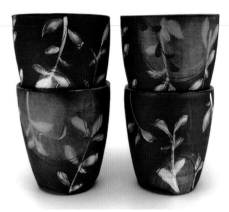

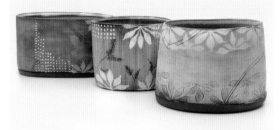

Heather Spontak, Tumbler Set Wheel-thrown black clay with colored terra sigillata, slip, sgraffito, cone 4 oxidation

Heather Spontak, Oval Vases Wheel-thrown and altered red clay with colored terra sigillata, slip, stencils, sgraffito, cone 4 oxidation

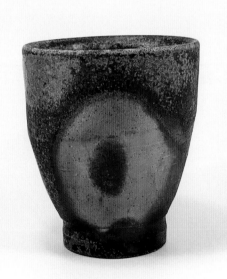

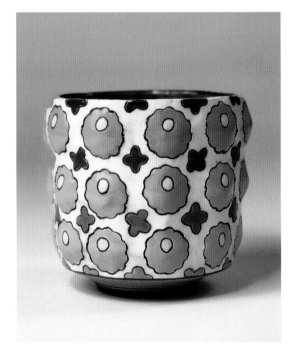

Gillan Doty, Cup, Wood-Fired

Sara Ballek, Bubbly Cup Wheel-thrown and pinched earthen red clay, white slip, Amaco Velvet underglaze, sgraffito, cone 4

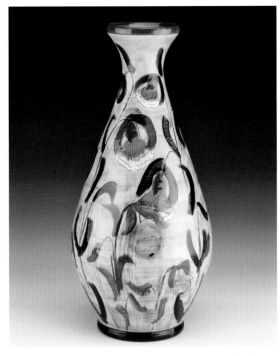

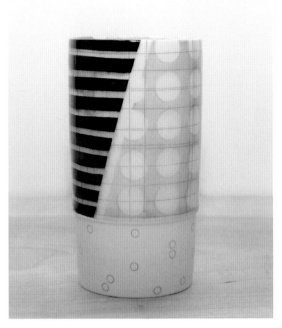

Ben Carter, Garden Vase Thrown and decorated with slip, underglaze, sgraffito, and glaze before being fired to cone 4 in an electric kiln

Rachel Donner, Tumbler

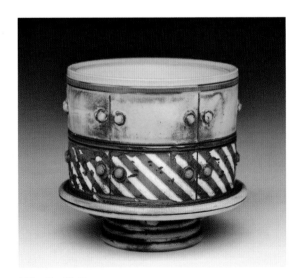

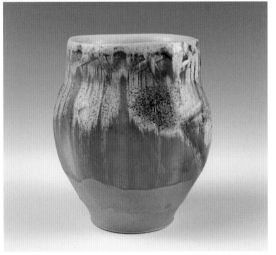

Mike Cinelli, Cup

Simon Levin, Yunomi Wood-fired

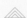

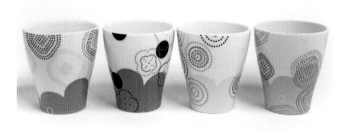

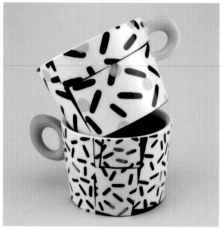

Meredith Host, Dot Dot Dash Juice Cups

Adrienne Eliades, Mugs Porcelain, wheel-thrown with pigmented slip-cast handles, underglaze and glaze decoration fired to cone 7 oxidation

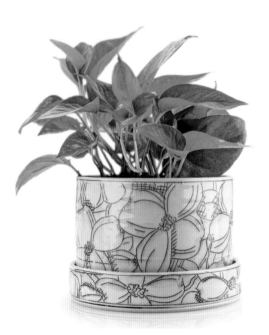

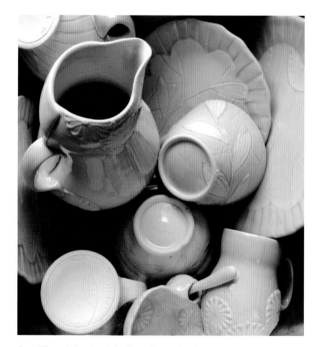

Laurie Caffery, Dogwood Planter Porcelain, underglaze and mishima, cone 6 oxidation

Jen Allen, dishes in sink Porcelain, wheel-thrown

Throwing on the wheel may be harder than it looks, but, with a little perseverance, you too can fill up a sink with your own dishes!

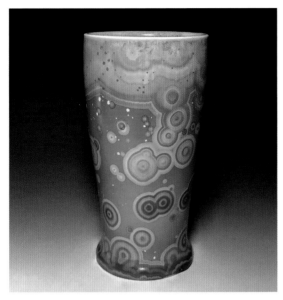

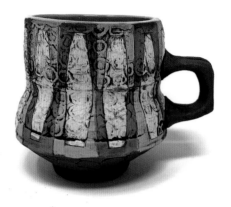

Ian Childers, Green Crystalline Tumbler Porcelain

Mark Arnold, Mug Red clay, colored terra sigillata, underglaze and glaze, press-molded and wheel-thrown

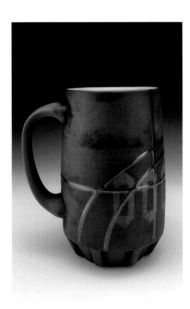

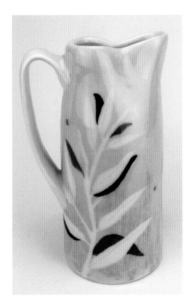

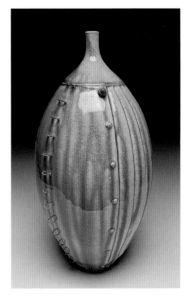

Eric Heerspink, Stein

Liana Agnew, Pitcher

Luke Doyle, Bottle Soda-fired in a wood kiln to cone 12

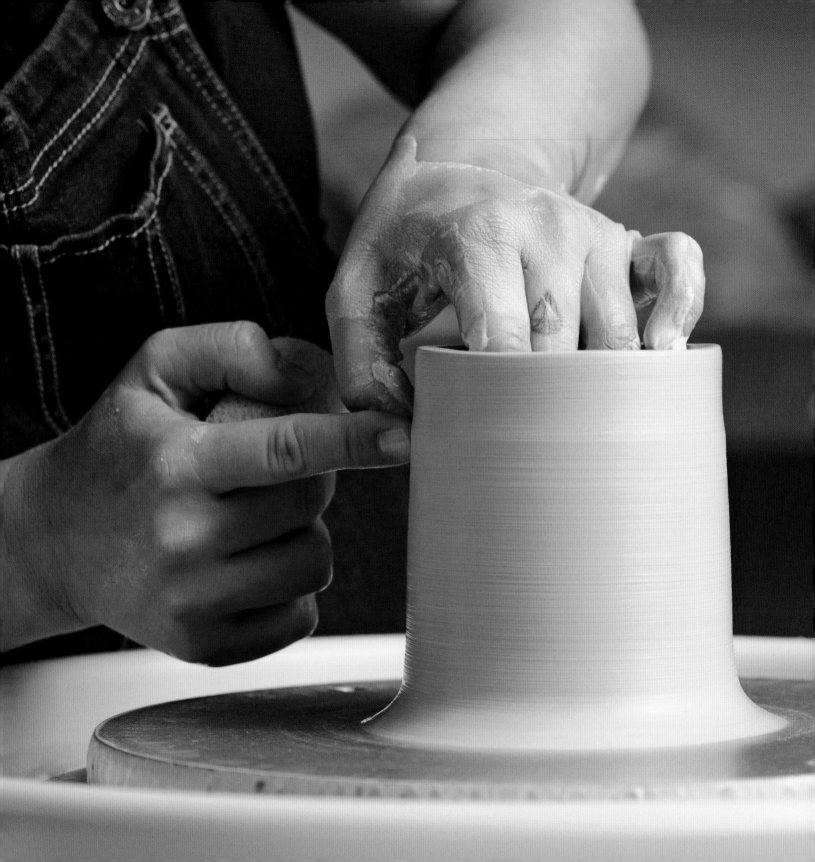

2
THROWING THE BASIC FORMS

When I teach beginner wheel, I start by asking each student what they are most excited about potentially making. In this chapter, I will run through the greatest hits, providing two options each for bowls, mugs, and plates. Remember that there are several ways to throw a pot on the wheel. I will guide you through the methods that work best for me and the majority of my students, including tips and tricks. You may find a slight variation that works better for you, or you may have learned a particular skill a different way in a workshop. That's great too.

Before you dive into throwing, take a few deep breaths, maybe even do some stretches and relax your mind and body. Remember, it is rare to attain perfection the first time you try something. It is okay if you flop your first pot . . . even your first few pots. What matters most is that you believe in yourself and keep trying. If you are patient with yourself, you will conquer this chapter.

TRADITIONAL BOWL

A good place to start after you understand the concept of centering and pulling is by throwing a bowl. The centrifugal force and movement of the wheel lends itself nicely to making a bowl, whether you intend to make one or not. In fact, you might find that most of your beginner pots resemble a bowl in one way or another. That is completely acceptable. There will come a time when you will be able to control your movements. Until then, roll with it.

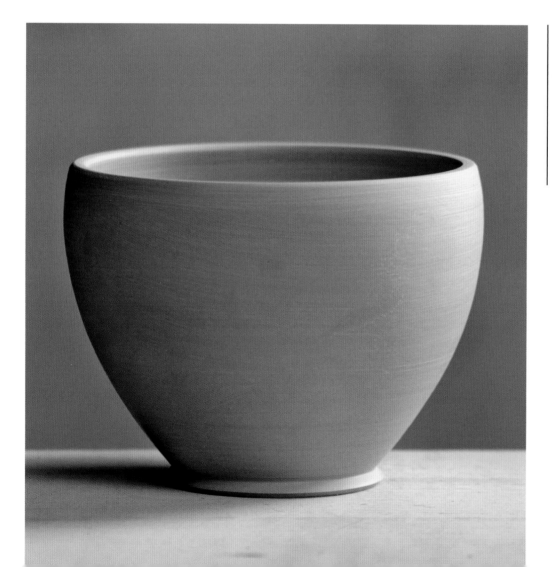

TOOLS AND MATERIALS

2 lbs. (907 g) of clay
wheel
bucket of water
sponge
wood knife
wire tool

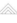

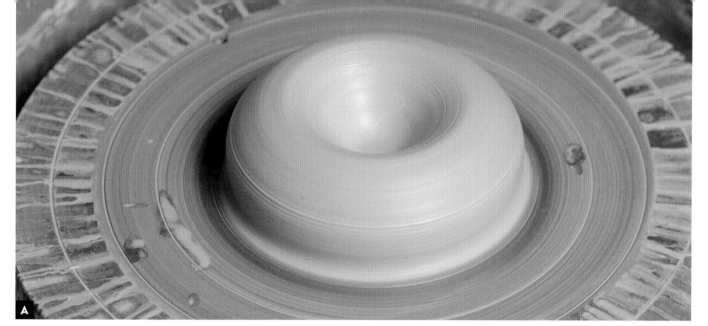

Instructions

STEP 1 Start with a centered ball of clay. Remember to use the stability of your left hand when coning down. Once you have a centered ball of clay, form the inside of your bowl. This technique is similar to throwing a cylinder but with some variation. With the wheel spinning and ball of clay moist, cup your hands around the clay. Bring your thumbs together, find the perfect center, and press down gently about 1 inch (2.5 cm).

STEP 2 With the wheel spinning, add a little bit of water. Using the same hand placement in chapter 1 (see page 24 step B), moisten your clay and begin pushing down until you are about ½" (1.27 cm) from the wheel head. What this should look like is an extremely thick bowl. **[A]**

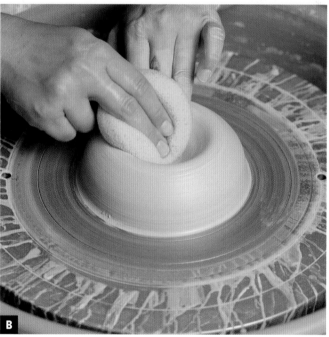

STEP 3 With the wheel spinning, use your sponge to gently compress the rim. It is important to do this after every movement as it will help keep your clay centered. It will also address any ultra-moist clay that has accumulated and prevent your rim from getting too weak or too thin. **[B]**

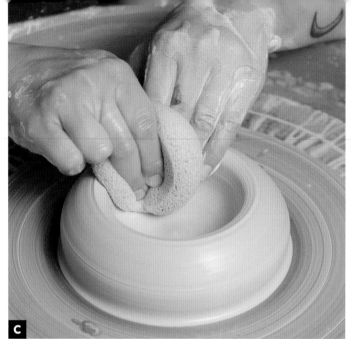

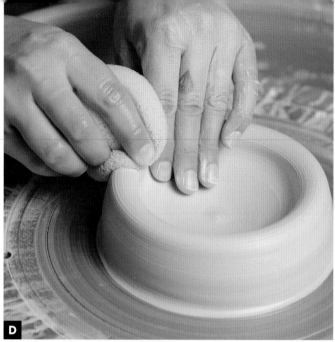

STEP 4 Using the same hand placement in step 2, open the clay to form the inside of your bowl. For this movement, I find it helpful to imagine you are feeling the inside curve of a bowl. This is the exact motion you want to make with your hands. With the wheel spinning, use a little bit of pressure and start pulling your hands toward you at 5 o'clock, moving upward as you move out. **[C]** Compress that rim.

TIP *When creating the inside of your bowl, use more pressure in the very center, then ease up as you are moving toward 5 o'clock. If you use the same pressure all the way through, you will end up with a flat bottom more suitable for a cylinder or a plate.*

STEP 5 Moisten your clay and repeat step 4, making your bowl wider and remembering to compress your rim gently once you reach the rim. With a bowl, it is important that you avoid overshooting this step. It is much easier to make a bowl wider than it is to make it narrower. For a standard cereal bowl, I recommend coming out no more than 4" (10 cm). **[D]**

TIP *You may have noticed that every step starts out "with the wheel spinning." This is very important to remember. You will have the most success when you establish your wheel speed before placing your hands on the pot. The same goes for stopping the wheel. You want to gently lift your hands off your pot before you stop the wheel.*

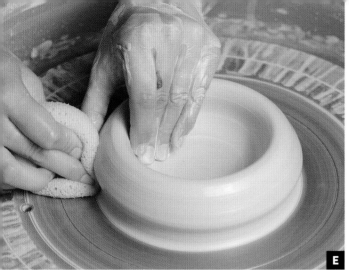

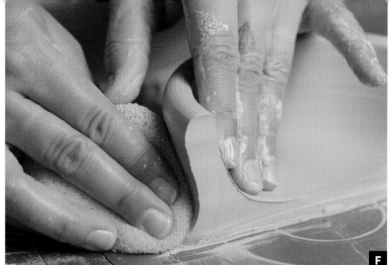

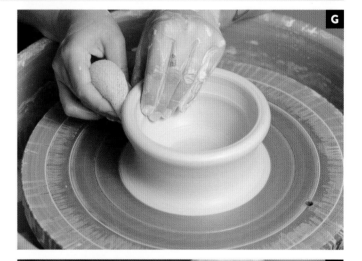

STEP 6 Now it is time to pull the walls, making your bowl taller and wider. With your left hand on the inside and your right hand on the outside, start pushing your hands toward each other and pulling up, being mindful to follow the curve of a bowl rather than go straight up. **[E]**

TIP *This step may seem much different than when throwing a cylinder. Due to the curve of a bowl, your hands may feel further apart and not perpendicular, making it harder to understand where to push and where your fingers should meet. My tip is to let your right hand move a little faster until you catch up to the same height as your left hand.* **[F]**

STEP 7 To make your bowl taller and wider, repeat step 6. This time be mindful that you are using equal pressure from both hands as you push your hands toward each other and pull up. **[G]** When you reach the top, compress that rim.

TIP *As your bowl starts to get thinner, so does the rim. At this point you should still be compressing after each pull, but be mindful that you might need to change your approach. Instead of using my sponge, I will often use my bare index finger. This reminds me not to push too hard and lose the progress I have made.* **[H]**

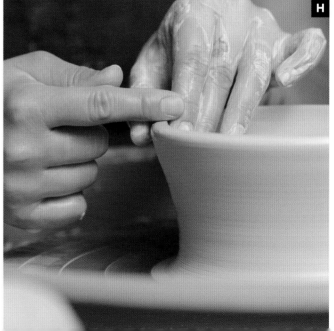

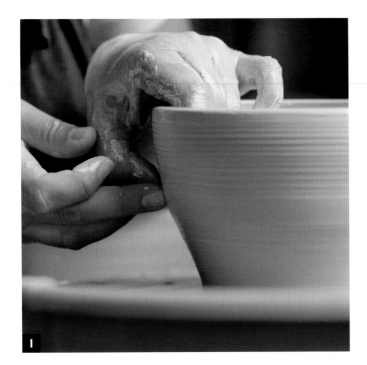

Why are my rims too thin? As you are pulling the walls of your clay, be mindful to ease pressure as you are clearing the top. One of the most common mistakes beginners make is getting so into the pull that they continue pushing their fingers closer together at the top. A too-thin rim will weaken the form and make it harder to expand the volume of your vessel.

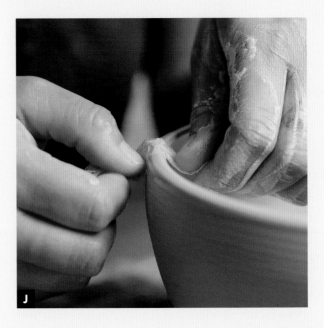

STEP 8 Your last pull. This step should merely be for shaping and refining. Staring down at the bottom of the clay and using the same hand placement in step 6, "pull" the walls of your clay following the shape of the bowl. This time be mindful to use more pressure in thick areas and lighter pressure when moving through thinner areas. As you clear the rim of your bowl, gently lift your hands up and off the rim. **[I]**

TIP *To round and perfect the edges of your rim, use a sham or a piece of plastic. I love using found objects, so plastic is my go-to material. Dip the plastic in water and with the wheel spinning gently, round the plastic over the rim of your bowl. **[J]** Voilà. You have a beautifully thrown bowl.*

TIP *If you have excess clay at the bottom of your bowl, use the technique of removing clay with your wooden knife as demonstrated in chapter 1 (page 27).*

TRADITIONAL MUG

There is no doubt about it, mugs are the most commonly used, desired, and collected form in the field of ceramics. It is an intimate object to some and collectible by many as the greatest mark of a maker. When it comes to making mugs, there are many things to consider, such as size/volume and form/shape. Before you get carried away dreaming up your signature mug style, it's a good idea to start with a traditional form to get the juices flowing.

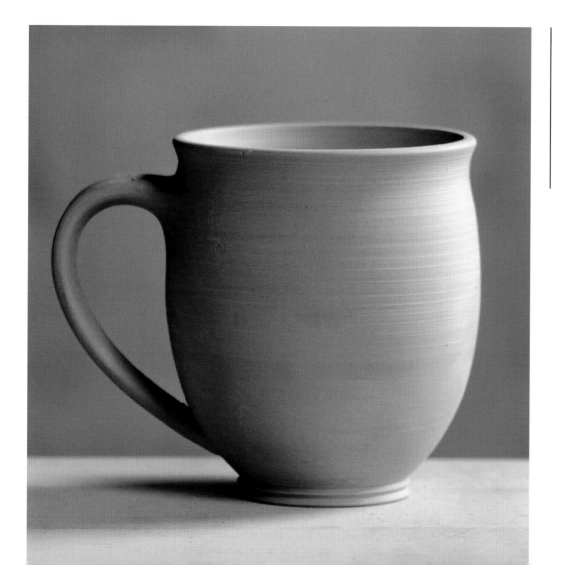

TOOLS AND MATERIALS

1.5 lbs. (680 g) of clay
wheel
bucket of water
sponge
needle tool
wood knife

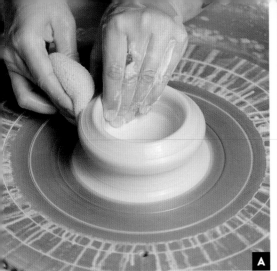
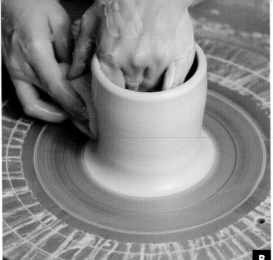
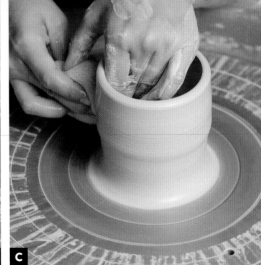

Instructions

STEP 1 Using the same methods as in chapter 1, start with a centered ball of clay. With the wheel spinning, cup your hands around the clay, find the center with your thumbs, and gently press down. As soon as your thumbs begin to resist the clay, add more moisture using your sponge. Continue pressing down until you are about ¾" (2 cm) away from the wheel head. Then with your left hand on the inside and your right hand on the outside, begin to open the form much like the cylinder in chapter 1. Only this time as you reach the outside, swoop your hands upward so that you have a gentle curve that will eventually mimic the curve of the finished form. **[A]**

STEP 2 Compress the rim. Repeat the movement of opening the form, only this time press down with a little force as you complete the movement. This compression will prevent the mug from cracking when drying and will also clear up any unevenness that may have occurred. Compress again.

STEP 3 Now you are ready to raise the walls. With your left hand on the inside and your right hand on the outside, start pushing your fingers toward each other at the base of the clay with even pressure and pull straight upward, just as with a cylinder. **[B]**

STEP 4 Compress the rim gently. Starting at the base of your mug and with the same hand movement as step 3, push out gently with your left hand to create a curve as you move upward. Then use even pressure to pull straight upward and toward the center. If you continue pushing with your left hand after the initial bump out, you might end up with a bowl instead of a mug form, so be aware of your movements. **[C]**

TIP *If you are having trouble differentiating between when you should be pushing out with your left hand versus when you should be pulling like a cylinder, think of the bottom of your cup like the butt of your cup. It's curvy at the very bottom.*

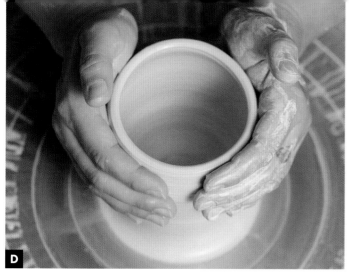

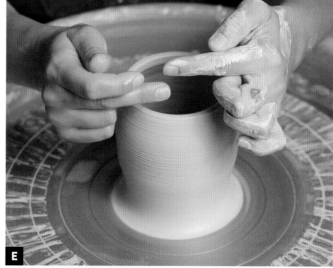

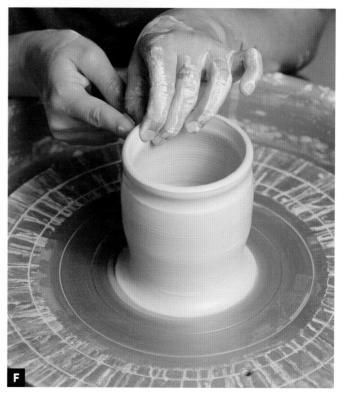

STEP 5 Repeat step 4. This will make your cup look a bit curvier at the bottom and a little taller at the top. When the walls are of even thickness, work with the lip of the cup.

TIP *If the top of your cup has gotten wider than you intended, you can fix this by cupping both hands around the top with the wheel spinning and gently pressing inward. Add fresh water to your pot before doing this step so your hands do not stick to the clay.* **[D]**

STEP 6 To form the lip of the cup, I use just my index fingers so that the movement is delicate. In this next step, finger placement is everything. **[E]** Making sure the lip is moist, position your left finger above your right finger just below the rim of the mug. Press in with your right finger and out with your left finger as the wheel is spinning to round the lip over the curve of your finger. Boom, you have a fluted lip. **[F]**

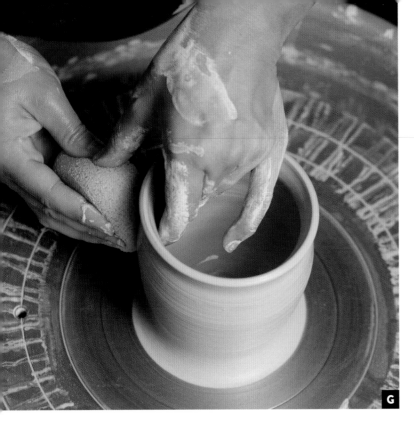

STEP 7 To make the lip wider or taller, this step can be exaggerated with another pull. This time keep your finger placement even. As you press your fingers toward each other, follow the curve of the lip and gently release at the top. **[G]**

STEP 8 Use a sham or piece of plastic to refine the rim.

Troubleshooting

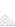

How can I fix an uneven rim? When one side of your cup is taller than the other, this is an indication that either your clay became uncentered at some point in the process or your pressure was uneven when pulling the walls of the clay up. If you press a little harder in one area versus another other, you are forcing the clay to rise more but only in that area. To fix this, I will show you a little trick. Do steps 1 and 2 in one fluid motion with the wheel continuously spinning until the moment the clay is successfully removed from the rim.

Step 1 Place your left index finger on the inside of your pot, close to but not touching the right side. With your wheel spinning, slowly come toward your pot with your needle tool in your right hand. Keep your right hand steady as you slice through the rim just below the lowest point of the lip.

Step 2 Once your needle tool makes contact with your left finger, lift up with both hands. This may take several attempts to gain success, so I recommend throwing a cylinder to practice on first. Remember, almost no one masters this on their first try, so be easy on yourself.

USING A BAT

Taking pots off the wheel is not a particularly easy task, especially if you have been working with the clay a fair amount and it is very moist and malleable. That's why I love using bats. Bats are flat disks or squares that attach to the wheel head and can be removed easily. They come in all shapes and sizes for use with everything from cups to large bowls. Bats come in a variety of materials, including plastic, wood, and plaster.

Most bats will come with two to four circular holes underneath or drilled straight through the material. These two holes will match up with the holes on your wheel head. To attach the bat to the wheel, you will need bat pins.

TOOLS AND MATERIALS

bat
bat pins
wing nuts
clay

Instructions

STEP 1 Take your splash pan off the wheel and attach the bat pins to the wheel. I recommend using wing nuts. The wing nuts will help keep the bat pins secure, which will come in handy when throwing larger forms.

TIP *To prevent the bat from wiggling, use a couple pieces of stiffer clay on the outsides of your bat or underneath. A wiggly bat can throw your pot off center or cause a hassle when pulling.* **[A]**

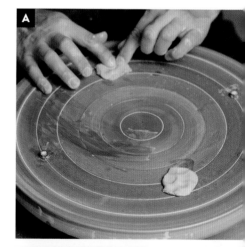

STEP 2 Next, line up the holes on your bat with the pins on the wheel and press down. Give your bat a little wiggle to secure it. **[B]**

TIP *Remove the bat pins, and wash and dry them after each throwing session. If you leave bat pins in your wheel head for long periods of time, they may rust or become corroded with clay, making them difficult to remove.*

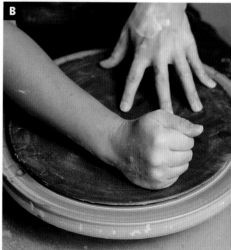

LUNCH PLATE

Now that you know how to attach a bat to the wheel, this is the perfect time to test the skill. It is possible to throw a plate without a bat, but it is nearly impossible to remove the plate from the wheel without one. If you forget the bat, you may end up with a taco-like form instead of a plate. For some, plates can be a great challenge and for others easier than expected. Plates require a bit more clay, making centering and opening more difficult. Take your time and enjoy the process.

TOOLS AND MATERIALS

bat

3 lbs. 5 oz (1497 g) of clay

wheel

bucket of water

sponge

wood knife

hard or soft rib

Instructions

STEP 1 Centering a plate is like cylinders and bowls except you really want to exaggerate the force when coning down. What you are looking for is a wide and shallow mound compared to a taller, narrower mound. To do this, use more pressure with your right hand and less pressure with your left hand. Wait, no even pressure? Yep, that is why I never say never. **[A]**

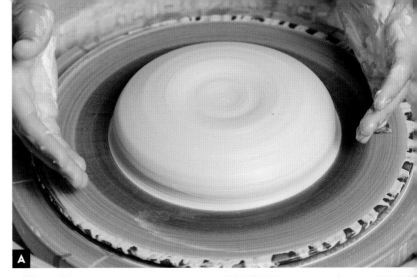

STEP 2 Make sure your clay is moist, and while the wheel is spinning, find the center with your thumbs. Gently press down using even pressure, making the smallest indentation.

TIP *It is easiest to find the center using the butterfly method (see page 24) if your mound is not wider than your wingspan.* **[B]**

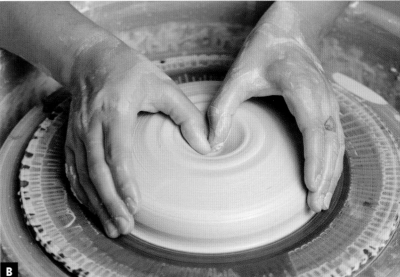

STEP 3 Next, grab your sponge with your right hand and with the wheel spinning, push down toward the center. This movement is easier with backup, so place your left hand on top of your right hand. Teamwork makes the dream work. Continue pressing down until the base of your clay is about 1½" (3.8 cm) thick. **[C]**

TIP *I have not mentioned this yet, but it is always a good idea to re-moisten your sponge and the clay in between each step. Slaking off excess moisture and clay slip by starting fresh will lead you closer to success in throwing.*

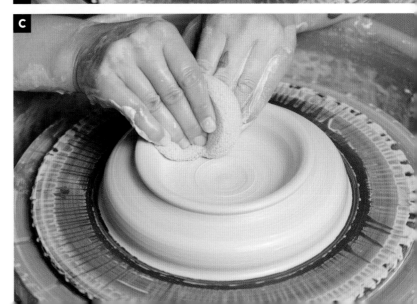

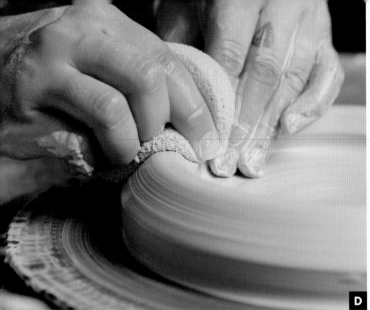

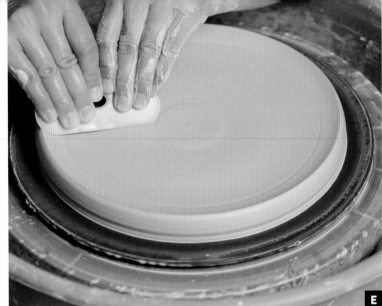

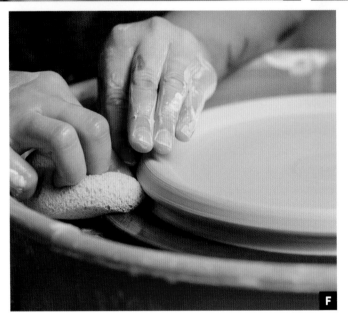

STEP 4 Next, use the same hand and sponge placement to push down toward the center and start pulling your hands and clay toward 4 o'clock. While you are pulling, use even pressure as you push down at the same time you are pulling out. You will end up with a thick mini plate with a thick rim. **[D]**

STEP 5 Compress the rim of your plate. Starting in the center, repeat the compressing movement, pressing down in the center and moving outward toward 4 o'clock. This movement will make your plate wider and the base more level and stable. Some potters repeat this step several times to ensure the bottom of the plate is compressed fully to prevent cracking during the drying process. **[E]**

STEP 6 When your plate has an even floor about ¾" (2 cm) thick, pull the rim of your clay. Using your moist sponge, come underneath the rim to lift it up off the wheel. Once there is enough space to fit your right index finger and middle finger, start pulling. **[F]**

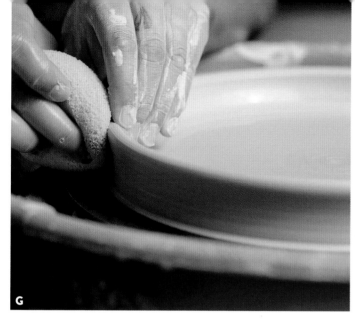

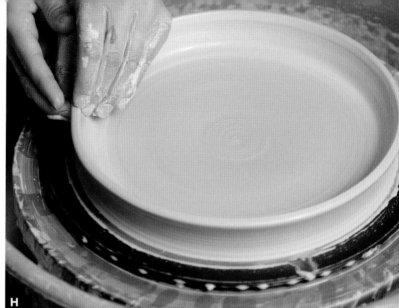

STEP 7 With your left hand on the inside of the rim and your right hand on the outside, press your fingers toward each other and pull upward. With this movement, focus on pulling up rather than out. The most common mistake here is pulling straight out, which puts your rim at risk of collapsing too soon. Do not forget to compress gently after the movement. **[G]**

STEP 8 Repeat step 7, this time allowing your hands to bring the rim outward. At this point, you have a pretty nice-looking plate. You can fuss with the rim a little more if you would like, but keep in mind that the more you fuss, the more likely the chances of your rim flopping down. If this happens, do not fret. How will you ever know your limits if you do not try? **[H] [I]**

STEP 9 Now there are a few finishing touches that I recommend. The first one is using a rib to smooth over all the compressing you have done. Starting just outside the center, use minimal pressure while the wheel is spinning and move outward until you reach the rim of your plate. This will create a level plate surface.

STEP 10 Next, use your wooden knife to lift under the base of the clay. This will help your wire tool find a smooth place of entry and exit. The most common mistake budding potters make when wire cutting plates is lifting too soon, causing the bottom of your plate to be uneven. I also recommend wire cutting your plate right on the wheel while your bat is secure. Congratulations. You just made your first plate.

Why are there big air bubbles in the floor of my plate? It took me a while to figure this out until I realized one especially important detail. It all comes back to compressing. When you are pulling the clay outward in step 5, make sure your rim does not over-shoot the base of the plate. If you overshoot the base and then compress down, you are trapping air and moisture underneath. **[A]**

Why is the middle of my plate too thick and near the rim too thin? This happens due to centrifugal force. As you are compressing the inside of your plate, your hands get more comfortable as you move outward, causing you to apply more pressure near the end of your movement. To correct this, start in the very center with your sponge and compress harder in the center, then ease up toward the rim. Use your rib to smooth this all over at the end. **[B]**

How do I dry my plate? Plates often take several days to dry, more time than a cup or a bowl. I recommend letting the rim stiffen up before covering the plate with plastic. At your next studio session, uncover it. I leave my plate on the bat until the base is stiff enough to be moved to a ware board. See more on drying in chapter 3 (page 70).

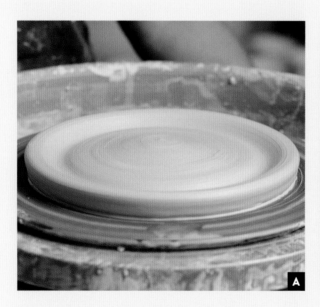

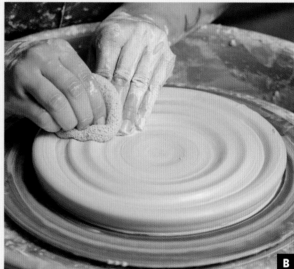

NOODLE BOWL

Now you should have an understanding of how to throw the basic forms. Once you have your aha moment when centering and pulling start to click, you will be able to throw almost any form. In this next section, I will guide you through expanding your throwing skill set by trying variations of the different basic forms.

Noodle bowls are generally taller and are narrower at the rim compared to traditional, everyday bowls. To successfully throw a noodle bowl, keep in mind that you will be working against the centrifugal force of the wheel. Your hands will want to naturally widen the clay, so be mindful of your movements. Let's dive in.

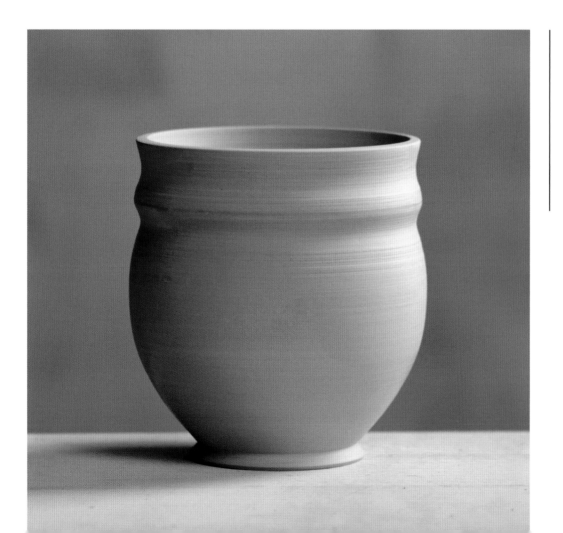

TOOLS AND MATERIALS

2 lbs. 5 oz (1043 g) of clay

wheel

bucket of water

sponge

wood knife

soft rib

wire tool

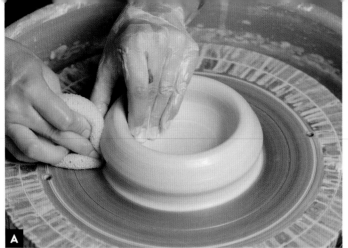

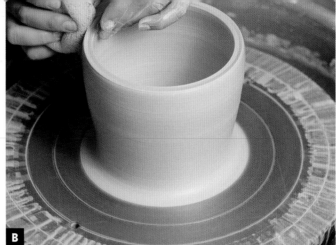

Instructions

STEP 1 Start with a centered and opened mound of clay.

STEP 2 Compress the very middle slightly. As you move toward the outside, swoop your hands upward. Compress that rim and add some water.

STEP 3 Throwing a tall noodle bowl is very similar to throwing a mug, only you are working with a bit more clay. With your left hand on the inside and your right hand on the outside, gently press your fingers toward each other, following the curve of the bottom, and pull upward at a vertical angle as you are nearing the top. **[A]**

TIP Remember to allow the wheel to spin one full rotation before allowing your hands to advance in the pull. This will keep your clay centered and pulling of the walls even.

STEP 4 Compress the rim gently and repeat step 3 until you end up with a tall bowl. **[B]**

TIP Remember to check in between pulls. If your bowl is getting slightly wider each pull (this is not something you want to achieve), use the cupping technique from page 43.

STEP 5 Now that you have a tall bowl, it is time to try something new. To create the bump out and perfect the lip, as pictured above, start about 1½" (3.8 cm) from the rim. Make sure this area of your clay is wet. With the wheel spinning, place your left index finger on the inside and position your right index finger so it's above your left and your middle finger so it's below the left. **[C]** As the wheel is spinning, push your left finger outward. Your right fingers will be controlling the movement, creating a nice curve. **[D]** Congratulations, you just learned how to "bump out" your clay.

STEP 6 The last steps are for refining. Use your fingers to refine the rim, and use a sham or piece of plastic if you want to smooth it over. **[E]**

STEP 7 Use your wooden knife to remove excess clay from the bottom, and a soft rib if you want to smooth over any throwing lines your fingers created. With the wheel spinning, place your left had on the inside and your right hand on the outside holding the rib. Starting at the bottom of the clay, slowly move your way toward the top. This is also a great way to refine the shape and remove excess moisture. **[F]** Way to go, you have a tall rice bowl.

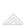

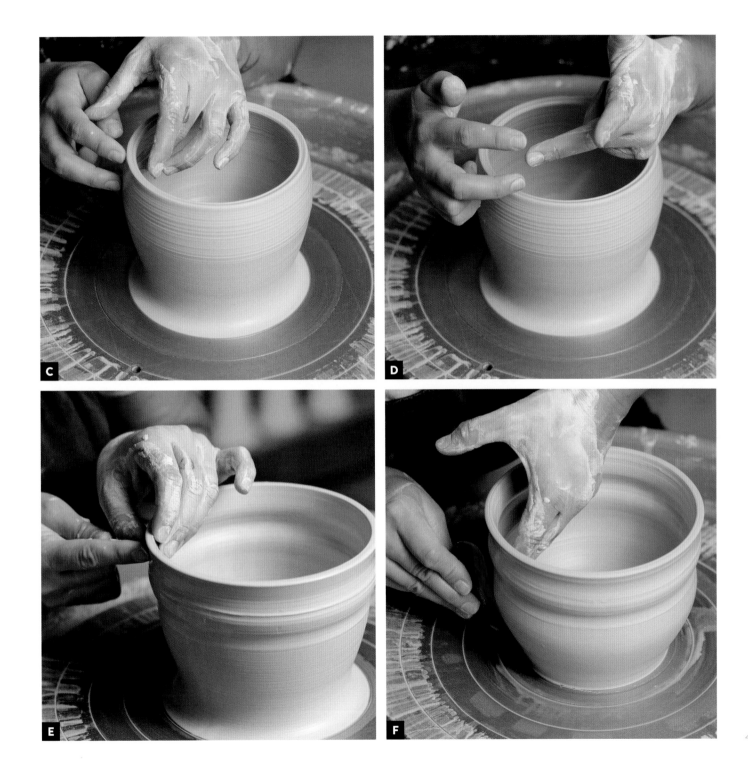

STACKING MUG

Learning how to throw stacking forms can be extremely useful. Not only are they aesthetically pleasing when stacked up, but they also take up less room in the cupboard and can be carried easily in a grouping. This particular stacking mug form came to me in my sleep. I hopped out of bed and sketched my idea before the image slipped from my mind. Once awake, I tried several different volumes and throwing techniques before I settled on the most successful method. Join me as I guide you through this process.

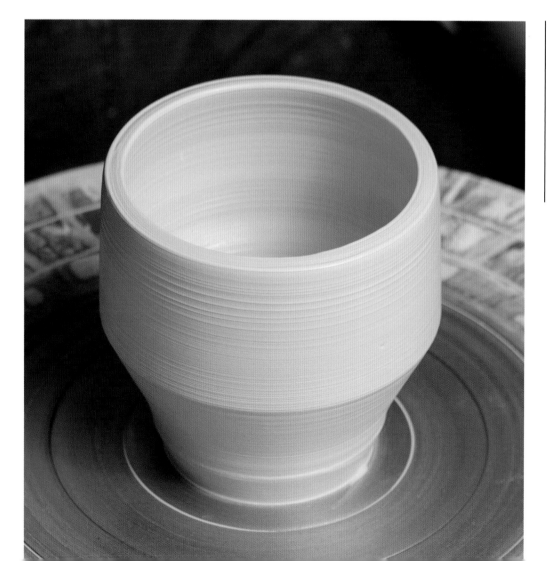

TOOLS AND MATERIALS

1 lb. 5 oz (590 g) of clay
wheel
bucket of water
sponge
wood knife
hard or soft rib
wire tool

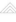

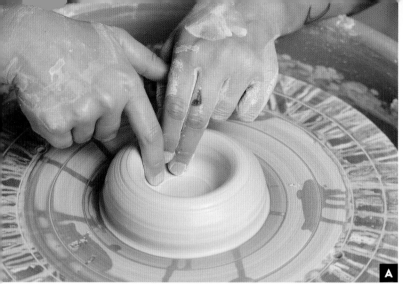
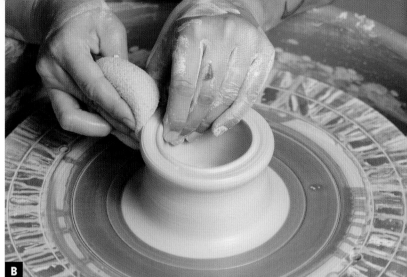
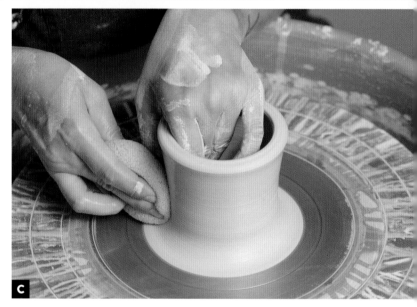

Instructions

STEP 1 Center and open the clay as you would a cylinder. The only difference here is you are only opening the clay about 1¾" (4.5 cm) wide. This may seem small at first, but it is easier to make clay wider than it is to make it narrower. **[A]**

STEP 2 For the first pull, pull the walls of the clay up like a cylinder, letting your hands wane slightly outward as you reach the top. **[B]**

STEP 3 The next pull is a little more exaggerated. Starting at the base with the same hand placement as in all other forms, pull the walls of the clay up and outward, forming a V shape. **[C]**

TIP *Keep the base of the clay the same circumference throughout the pulling process. I have found it is easiest to add a little more pressure with my right hand at the very bottom, then ease up as I reach the top.*

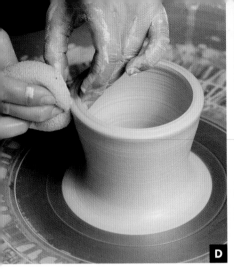
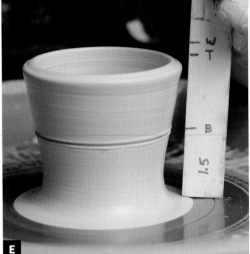
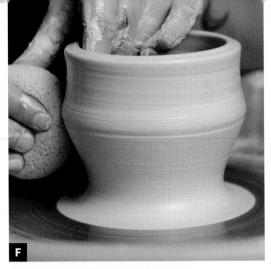

D

E

F

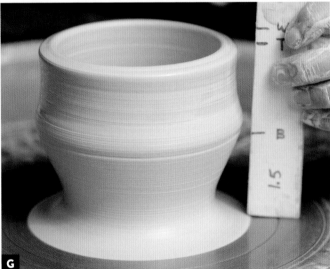

G

STEP 4 Repeat step 3 until you reach just about the height of your cup. **[D]** Have you been remembering to compress the rim after each movement?

TIP *You may have noticed that my stacking mug form seems to be identical. This is purposeful. For this style of mug to stack perfectly, it helps if the forms are around the same shape and size. To do this does not require memory or magic, just lots of practice and careful planning. I use a ruler to measure key points, such as the base, height, and width. Some potters use what is called an armature while others use rulers. I prefer the ruler method. I was gifted a box of rulers in college, and they have become my favorite tool in making multiples. Before you start measuring and replicating shapes, I recommend making a few or several as tests first. To create this stacking form, I tried a few different shapes and sizes, marking the base height, lip width, and height of the mug upon throwing. Once they were finished, I went back to my rulers to pick my favorite.*

STEP 5 Here comes the fun part. This next step can be challenging for beginners, so if you flop your first few, remember it is all part of the learning process. Use your ruler to mark the height of the base. **[E]** Starting at the bottom of the cup, press inward and pull at a sharp 90-degree angle until you reach the reference line. **[F]** Phew, you made it. **[G]**

TIP *Make this a small movement to begin with. You can always go back and repeat the step if you do not make it on the first pull. In fact, I typically do this step twice just to make sure my base is an adequate thickness and at an even angle.*

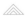

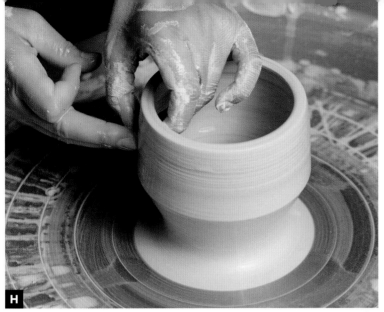

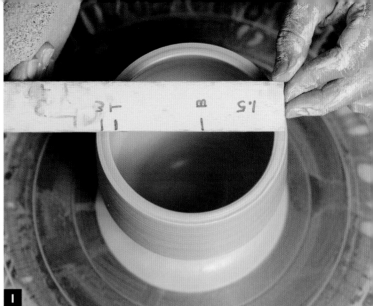

STEP 6 Next, pull the rim up. Starting just above the baseline, press your fingers toward each other and pull straight upward. Check the height and width to see how close you are. **[H]**

STEP 7 It is likely that you will have to do one more pulling. Repeat step 6, making sure you are pulling straight up and not outward—unless, of course, a wider rim is what you are going for. A wide-mouthed form is not so perfect for delicate sipping but can be super useful as a bowl form. **[I]**

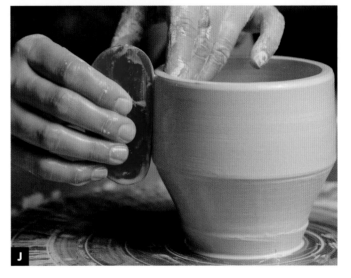

STEP 8 Your mug is finished when you are happy with it. My last step, besides using my wooden knife to remove excess clay at the bottom and refining the lip, is using my rib tool to make sure the walls of my mug are perfectly vertical. **[J]** I do this mainly because my mountain decals (page 131) rely on a flat surface to be applied smoothly, and because I am a perfectionist.

PASTA PLATE

Pasta plates are distinct to serve a specific function. They are rounded more than they are flat to prevent sauce and juices from flowing over the rim. Throwing a pasta plate on the wheel is the merging of the techniques for both a bowl and a plate to form a curved base. Every potter has a different method for throwing pasta plates, so I will guide you through the method that has worked the best for me.

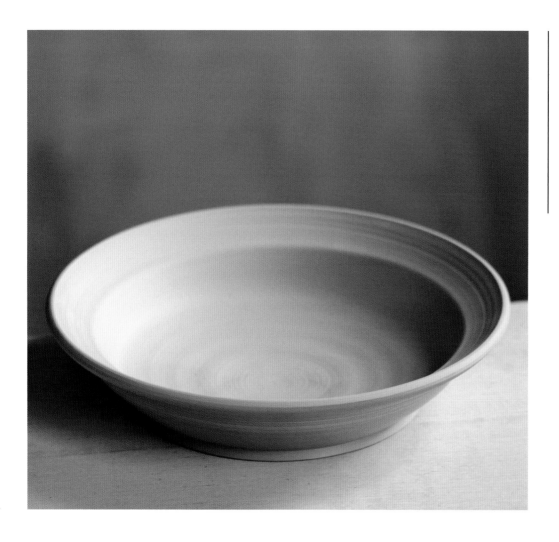

TOOLS AND MATERIALS

4 lbs. (1814 g) of clay
wheel
bucket of water
sponge
wood knife
hard or soft rib
wire tool

Instructions

STEP 1 Starting with a centered ball of clay, find the center and open the inside just like I demonstrated with the plate on page 47. Do not forget to use a bat. **[A]**

STEP 2 Pulling out the walls of a pasta plate is virtually the same as pulling out the walls of a traditional plate except that you want to create the motion of feeling the inside of a bowl as you are nearing the rim. This will help you create the curved-base form you need. So instead of pulling straight up, swoop your hands upward as you are pulling out toward the rim. **[B]**

STEP 3 Repeat step 2 a few times, being mindful to place more pressure in the direct center, then ease up as you reach the rim. This will end up looking like a wide and shallow, thick bowl. **[C]**

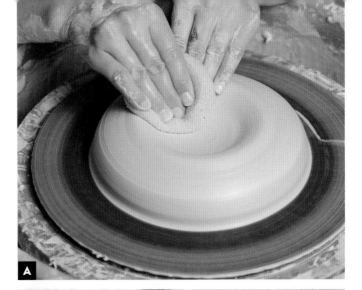

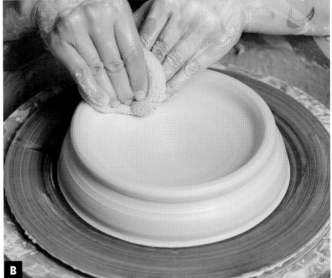

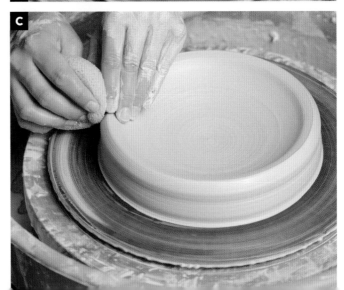

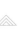

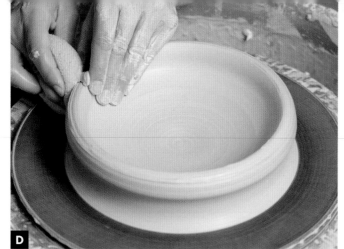

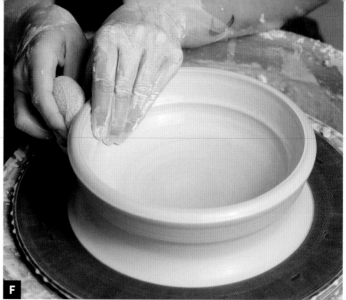

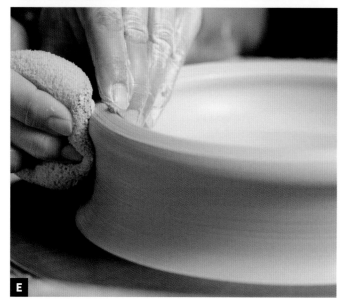

STEP 4 Now pull up the rim. This can be a little tricky. With your left hand just below the curve of the rim and your right hand on the outside at the base, push in with your right hand and move your left hand at the same speed as the wheel, traveling upward following the curve (using minimal pressure) until you reach the same level as your right hand. **[D]** In the same movement, press your hands toward each other and pull straight up following the curve's angle. **[E]**

STEP 5 If you are making a shallow bowl, repeat step 4 until the appropriate thickness is achieved. **[F]** If you want to create a rimmed pasta plate, follow the next steps.

STEP 6 One of the reasons pasta plates require more clay is because of their curve and rim. If you find that you do not have much clay left to create a rim, it may be because you pulled the base of the plate out a little too far. To create the rim, position your fingers about 1" (2.5 cm) from the lip. Your right finger will go below your left. As the wheel is spinning, keep your right finger stationary while your left finger moves at the pace of the wheel, curving over your right finger. If you are a beginner, this might be a nice place to stop. **[G]** If you are feeling daring, try making that rim a little wider and flatter.

TIP *Wherever you position your fingers initially, whether it is a ½" (1.27 cm) from the rim or a whopping 2" (5 cm), that is how wide your rim will be. The wider the rim, the more challenging it will be to keep its form. I recommend starting small and working your way up.*

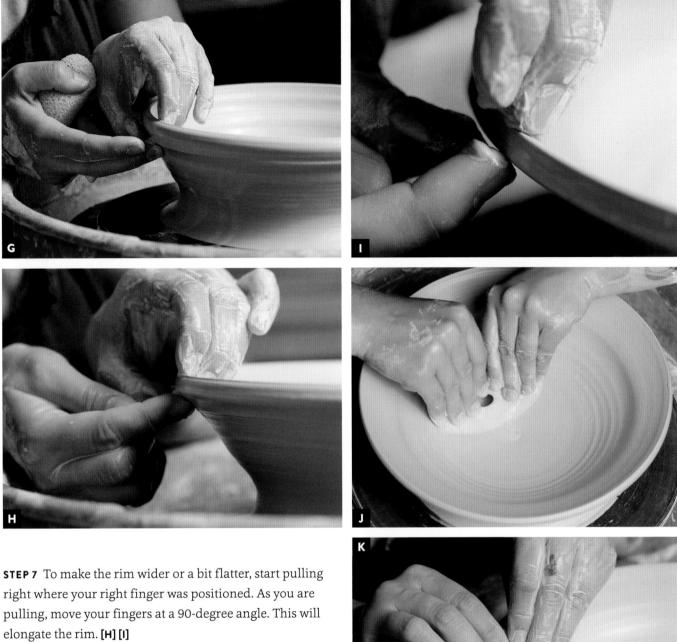

STEP 7 To make the rim wider or a bit flatter, start pulling right where your right finger was positioned. As you are pulling, move your fingers at a 90-degree angle. This will elongate the rim. **[H] [I]**

STEP 8 Using your rib, compress the inside of your plate using minimal pressure. This will refine and smooth that gentle curve. If you are a beginner, this would be a marvelous place to stop too. If you want to push the limits, grab your rib and as the wheel is spinning, gently press the rim downward, stopping once the rim is parallel to the wheel. **[J]** You now have a wide-rimmed pasta plate. Way to go! **[K]**

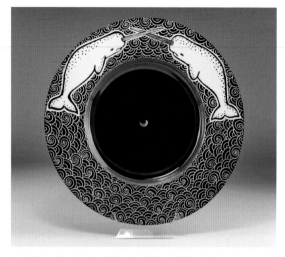

Anja Bartels, Narwhal Blessing Plate Wheel-thrown porcelain, fired to cone 7 electric, sgraffito decor, gold luster, four layered glazed in interior

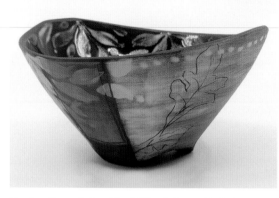

Heather Spontak, Leaf Bowl Wheel-thrown black clay with colored terra sigillata, slip, sgraffito, cone 4 oxidation

A simple way to alter the rim of a piece is by slicing through the clay with an X-ACTO knife, as shown on Heather's bowl. This process should be done just before the clay reaches the leather-hard stage.

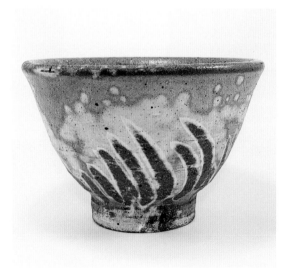

Gillan Doty, Bowl Wood-fired

Sara Ballek, Rimmed Plate

Sara's work is wheel-thrown and altered through a multitude of finger-pinching techniques—a beautiful example of how to transform a rather simple form.

Deb Schwartzkopf, Stack of Plates Wheel-thrown and altered porcelain, cone 6 electric with underglaze dots

Deb Schwartzkopf, Bowl Wheel-thrown and hand-built porcelain, cone 6 electric

Ian Childers, Orange Crystalline vessel Porcelain

Mike Cinelli, Mug

Meredith Host, Dot Floral Dinner Plate

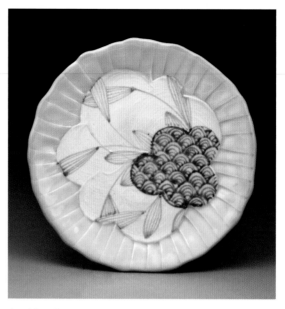

Jen Allen, **Dinner Plate** Porcelain wheel-thrown

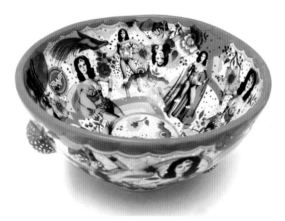

Mariko Paterson, Wonder Woman Pho Bowl

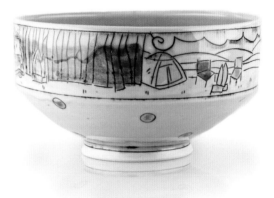

Laurie Caffery, **Camping Soup Bowl** Porcelain, underglaze and mishima, cone 6 oxidation

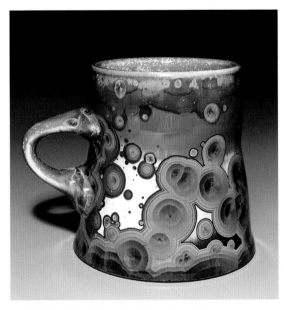

Ian Childers, Blue Crystalline Mug Porcelain

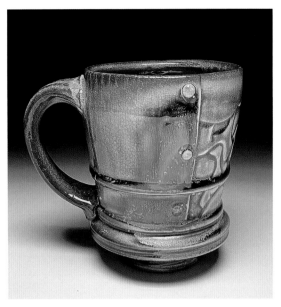

Luke Doyle, Mug Soda-fired in a wood kiln to cone 12

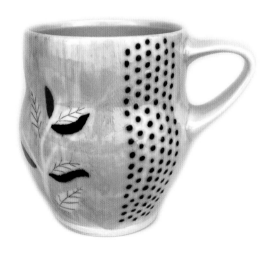

Liana Agnew, Mug

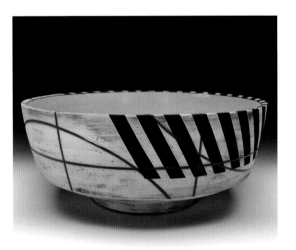

Eric Heerspink, Bowl

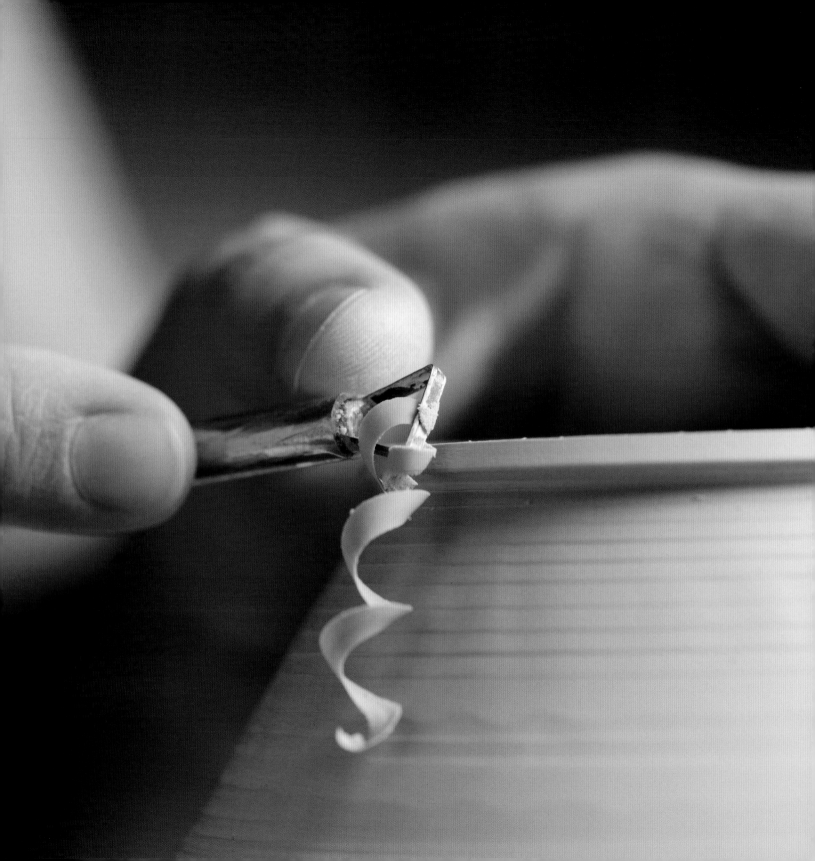

3

UNDERSTANDING CLAY AND TRIMMING

Throwing on the wheel is the first step to making beautiful pottery. What comes after sets the tone for developing a personal aesthetic. When I was a beginner, I put all of my focus into throwing a perfectly balanced pot. As my skills grew and my throwing time decreased, I realized there was still so much more that could be done. In this chapter, I will discuss the working stages of clay and how to tell when a pot is ready to trim. I will lead you through fearlessly trimming a "foot" and get you acquainted with making and attaching handles. Warning: After you finish this chapter, you may go about checking the bottom of every cup, mug, and bowl that you see. Once you learn the process, it's fun to see what other potters are doing and how they finish their bottoms.

TIP *First check that there isn't liquid inside!*

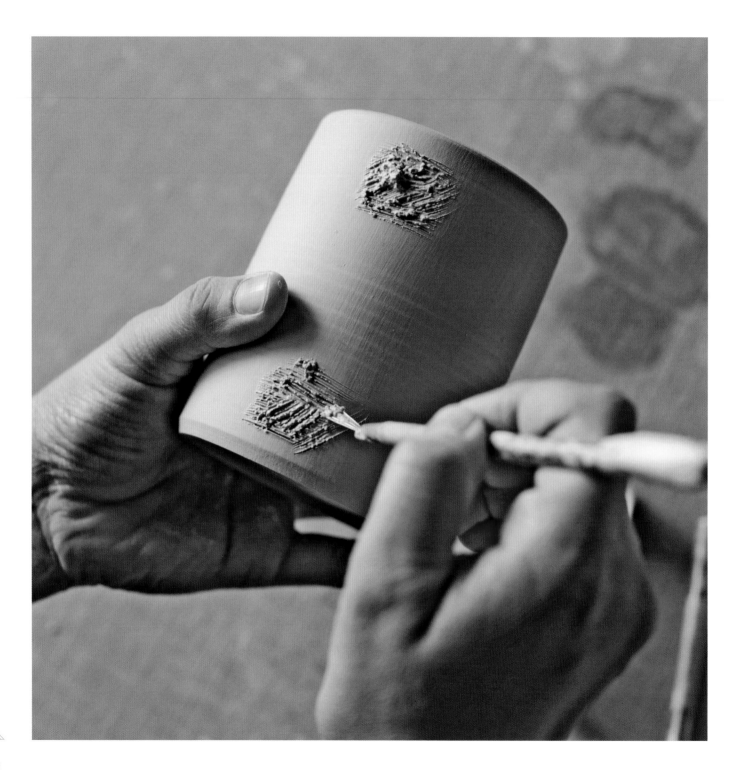

THE STAGES OF CLAY

As you have no doubt figured out, clay will eventually dry. How fast or how slow depends on how you manage it after you make your pot. Knowing what to do and when can be tricky at first. In fact, the most common question I receive as a teacher aside from "Is this centered?" is "Are my pots ready to be trimmed?"

The good news is that the tools you need to ensure even drying are accessible and inexpensive. Dry-cleaning bags and trash bags can be used to cover your works in progress. Your studio may also have wet boxes or dry boxes for communal use, though these are more of a perk than a necessity.

The Key Stages of Clay

DRY: This refers to the powder stage of clay before water is added. You may never see your clay in this form unless you plan to mix your own clay body.

SLIP: This refers to liquid clay, which can be used for slip trailing decoration and also for slip painting. It can be used like glue for attaching two pieces of clay or in the process of mold making called slip casting.

PLASTIC OR WET: Clay you can easily mold. This includes clay straight from the bag and freshly thrown pots. Clay is most workable for hand building and throwing at this stage.

SOFT: In between plastic and leather. This clay is slightly harder than clay straight from the bag and is no longer wet or easily malleable. However, it is soft enough to smudge. It is perfect for slicing and dicing, alterations, adding handles, and darting.

LEATHER HARD: This clay is stiff, no longer tacky to the touch, and unable to change shape. It is the consistency you want for trimming, carving, attaching handles, and decorating with slip or underglaze.

BONE DRY OR GREENWARE: This refers to clay that is completely dry. All the water has evaporated from the pot. If the pot is cool to the touch, that would indicate there is still moisture inside and it is not yet bone dry.

BISQUE: Clay that has been fired once is considered bisque or bisqueware. There is no chemical water left in the clay at this point, making it porous and better able to accept glaze.

GLAZE WARE: Finished pottery. This refers to clay that has been glaze fired and vitrified to maturing temperature. Generally, only glaze ware is watertight.

DRYING POTS

Drying your pottery properly is crucial for success in trimming. After throwing, it is best to leave your pots uncovered until the tops begin to stiffen up a bit. This means they should not be tacky to the touch. At this stage, cover your pots loosely with plastic, allowing the bottoms to catch up.

If you cover your pots immediately after throwing, the plastic may stick to the wet clay and deform the shape. If you absolutely need to cover your pots immediately, be creative. Place taller found objects in between your pots so the plastic rests on them and not your fresh rims.

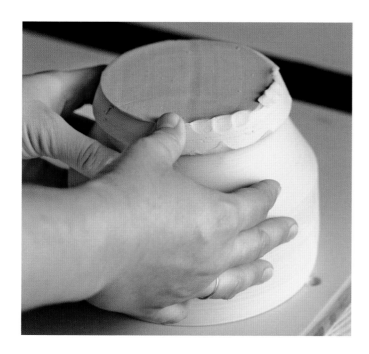

When the bottom of your pot is soft and the rim is stiff enough to maintain its shape, carefully flip your pot upside down. This will allow the bottom to catch up to the rim for an even, leather-hard pot. It may take a few days of uncovering and re-covering depending on the conditions specific to your studio. Humid climates and dry climates can affect the drying differently.

Once your pot is leather hard, you are ready for trimming. This stage may be difficult to detect, so I suggest testing the bottom of your pot by sinking your nail in it. If you can see your fingerprint clearly, along with your nail indentation, the pot might need to dry a little more. While most potters I know trim at this stage, it is a personal preference. Some people prefer to work a tad wetter, and that is okay too.

Troubleshooting

Why are my pots drying unevenly? You may notice your trimming tool making a deeper impression on one side of the pot versus the other. If your pot is centered, this is probably a drying issue. The best way to ensure even drying is to rotate your pots in evenly timed intervals. Airflow is how pots go from wet to bone dry, so unless your pots are constantly spinning on a turntable, chances are they are not getting even flow. Every environment has its own set of conditions. For instance, during winter months when the heat is on, pots tend to dry faster, whereas in the summer when humidity is at its peak, pots tend to dry slower.

If my pot is too dry, is it too late to trim? The general rule of thumb is once your pot reaches bone dry, it is indeed too late to trim. I am sorry, as I loathe giving people this news. If you try to trim at this stage, your rim may crack while securing the pot to the wheel. In addition, your trimming tool, while barely making an impression, will spit out dry shavings of clay and dust, which is hazardous to inhale.

Can I re-saturate a mostly dry pot? You can try. If it has not totally crossed over to bone dry, you might be able to revive it. I don't recommend dunking it in water as this might shock the clay into cracking. Instead, wrap a wet towel around the piece, then re-cover it with plastic. It may take a few hours to regain enough moisture, but slow is better than fast to avoid cracking.

Why is it so difficult for me to master the stages of clay? Pottery is a creative process. When we let loose, it's easy to get caught up in the fun stuff and forget about the nuts and bolts of the "boring" stuff like managing drying. It can also be difficult to get to the studio as often as you like. If you make a mistake, rather than getting discouraged, remember that you have just expanded your knowledge. If your pots are drying too fast, find a way to wrap them differently or start a buddy system to help manage the drying over the course of a week.

TRIMMING

Trimming refers to the process of taking away excess clay and refining the bottom, or foot, of a pot. Trimming makes pots lighter, smoother, and less likely to damage the surfaces they are placed on. It also lets you beautify the bottom of your pot to make it more aesthetically pleasing. For the best success in trimming, I recommend following the inside shape of your pot. This will leave the walls of your vessel with even thickness and makes the most sense aesthetically.

Before you attach your pot to the wheel for trimming, you should check the thickness of the walls and base. This will give you a good idea of how much clay to trim off. If you forget this step, there is a chance you might trim right through your pot. Don't fret, this is something all potters have done before. After all, how better to learn the look and feel of a pot that has been trimmed too thin than to experience it yourself?

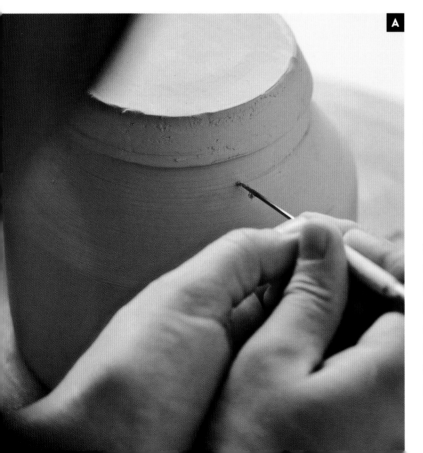

TOOLS AND MATERIALS

leather-hard pot
needle tool
fresh bagged clay
trim tools
sponge
water
wheel

Securing a Pot to the Wheel

STEP 1 Flip your pot upside down and use the lines on the wheel to position your pot in the center. Lightly press your foot on the pedal. While the wheel is spinning slowly, carefully move inward with your needle tool in hand. Slowly move your needle tool toward the foot of the pot. As your tool starts to make an impression, keep your hand steady and stationary. If your pot is off center, the tool will make a line on only one side of the pot. **[A]**

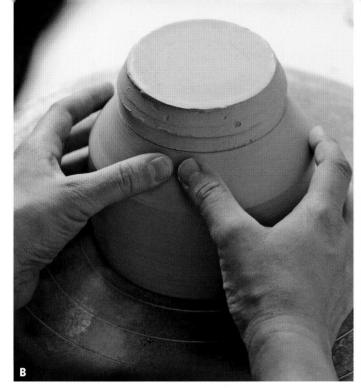

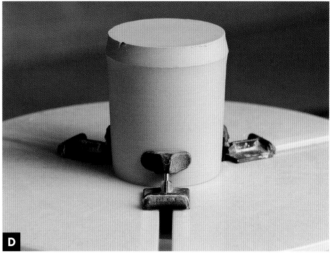

TIP *What you want to avoid is letting your needle tool move the pot. This will give you inaccurate centering results.*

STEP 2 Stop your wheel and find the middle of that line and gently push the pot toward the center of the wheel. Small movements are best. Repeat this step until the needle tool makes a complete line around the pot. Now it is centered. **[B]**

STEP 3 To secure the pot to the wheel, grab fresh clay from the bag and roll it into three balls, also called lugs. Use four lugs for large or wide pots. Place one hand on top of the pot and, using your other hand, press the lug at the rim of the pot where it meets the wheel. If you forget to place your hand on top of the pot while securing the pot to the wheel, you might accidentally move it off center. If this happens, go back to step 1. No big deal. **[C]**

STEP 4 Repeat evenly for the other lugs. Finding the right amount of pressure is crucial. If you press too hard, you risk altering the rim or moving the pot out of center. Once your lugs are in place, give your pot a little wiggle to secure it. If you forget this step, your pot might fly off the wheel.

TIP *The Giffin Grip is one of my absolute favorite tools. It centers and holds your pot in place to allow for easy trimming and less waste by omitting lugs. The only tricky part is, it works best on centered, symmetrical pots. It generally cannot work magic on wonky pots but is an amazing tool once you are able to throw a centered pot.* **[D]**

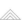

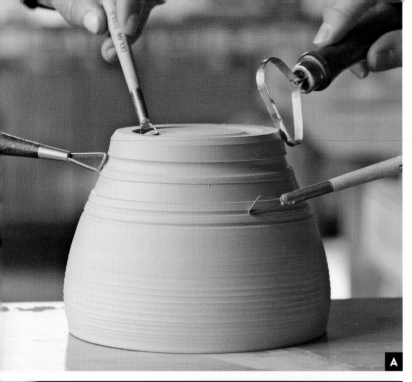

Let's Trim

With your pot attached to the wheel, start trimming. There are various shapes and sizes of trimming tools, and each one makes a different impression. Before you grab one out of your toolbox, take a moment to see which one speaks to you. **[A]**

STEP 1 Start spinning your wheel at medium speed and move toward the side of your pot with the larger of the trim tools. In this step, you are removing excess clay, bumps, and crumbs. Don't hesitate with your movement. Hold onto your trim tool tightly and only stop the wheel once you have moved your hand away from the pot. **[B]** Do the same with the bottom of your pot.

TIP *Just with throwing pots, you want to start with the wheel spinning and stop spinning the wheel once you have lifted your trim tool off the clay.*

STEP 2 Now that you have a smooth, workable bottom, it is time to decide where you want your foot to be. Mark this with your nail, needle tool, or trim tool. For the purpose of this demonstration, I will use a bowl, which is the most common of the beginner shapes.

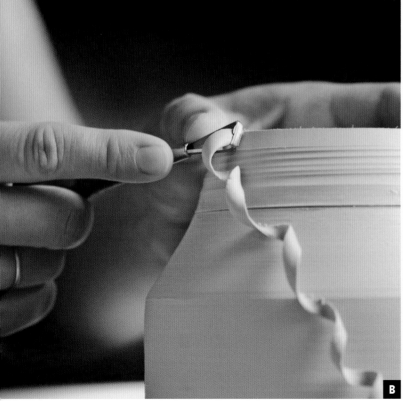

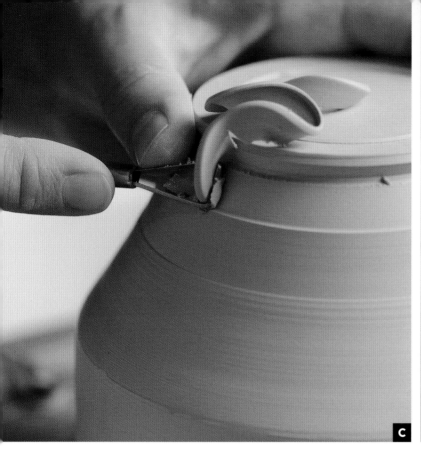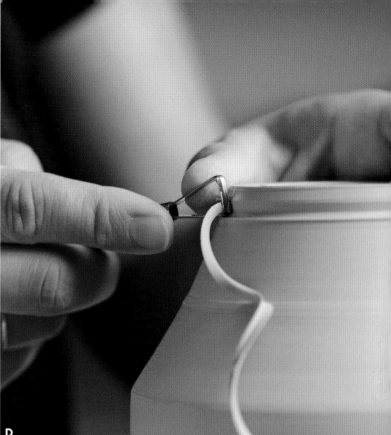

STEP 3 Start spinning the wheel at medium speed and begin trimming the outside of the foot until you reach the desired width. Once you have your desired depth and width, use the flat edge of your trim tool to round or angle the top edge of the foot. **[C]**

TIP *I like to undercut my feet. It provides a nice landing spot for glaze and is also aesthetically pleasing. If you are interested in trying this, use the flat edge of your triangle tool to cut under the clay.* **[D]**

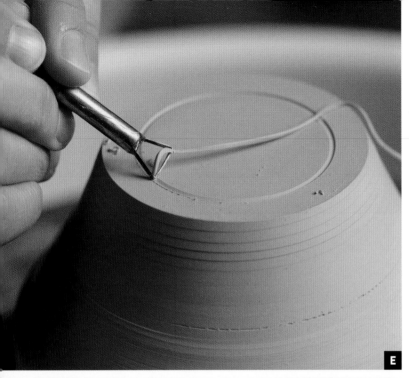

STEP 4 Using the same trim tool and the same wheel speed, begin carving the inside of the foot. I find it is easier to decide first how wide you want the foot to be and make that indentation with the edge of your triangle tool before you start carving out the middle. **[E]**

STEP 5 With the wheel at medium speed, begin trimming the inside of the foot. Start to the right of the center mark and work your way toward the inside edge line. If you are too hasty in your movements, you could trim the foot right off, so be aware of where you are spatially. Continue trimming until you are happy with your results. **[F]**

STEP 6 Optional: Once you have a nicely trimmed foot, some potters come in with a damp sponge to smooth their foot. I typically skip this step and opt to wipe my pots once they are bone dry. I do this because there is still a chance, at the leather-hard stage, that my pot will endure bumps and scrapes from movement on ware boards.

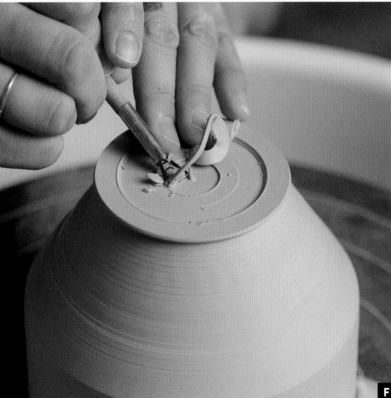

Using a Chuck

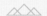

In the wide world of pottery making, you will likely encounter a form that is difficult to trim. As your skills in wheel throwing grow and you move on to chapter 4, you might find yourself experimenting with bottle- or narrow-necked forms. These forms are challenging to throw but delightful once you garner success. The only question is, how do you trim them? Using clay lugs at the mouth of a bottle form is risky. It is unlikely that it will stay put while trimming, and the Giffin Grip poses the same threat. This is when I recommend using a chuck. A chuck is an hourglass form that is meant to aid in the trimming of bottleneck forms. While most community clay studios will have these easily accessible, you could also make one from scratch. A chuck can be bisque fired for easy use over and over, or it could be thrown the same day as trimming and force dried to leather hard using a torch. Using a chuck is easy if you follow the instructions below.

Step 1 Place the chuck on the wheel and center it by testing the wheel at a slow speed. Place lugs at the base of the chuck as you would a pot for trimming. **[A]**

Step 2 Flip your pot upside down, place it in the chuck, and spin the wheel slowly to center it. If you need to, use the needle tool method. Once your pot is centered, secure it with lugs to the chuck. **[B]**

Step 3 Trim away. **[C]**

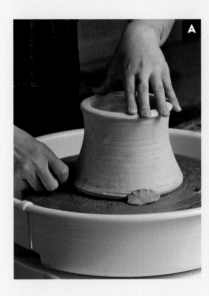
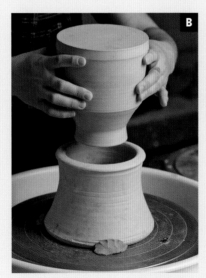
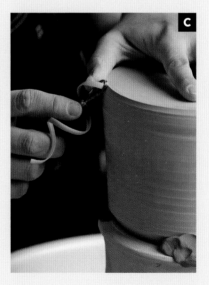

HANDLES

If you plan to attach a handle to your form, the best time to do so is after trimming when your pot is still leather hard. Most handle-making processes require you to use wet clay. To ensure your pot stays leather hard while your handle is drying, simply cover your pot well with plastic or use a damp box. There are several ways to make handles and several opinions as to what handle looks best with what form. In this section, it is my goal to give you a head start into the handle-making world and get you thinking about comfort and design.

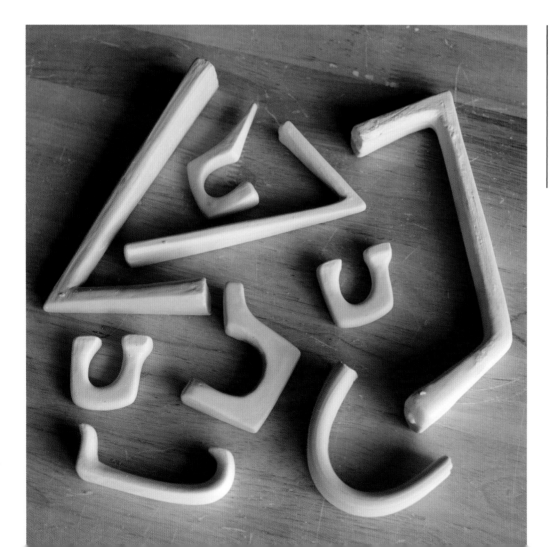

TOOLS AND MATERIALS

wet clay
bucket of water
X-ACTO knife
rolling pin
ware board
pencil and paper

When making handles, first ask yourself what kind of handle you prefer. Let this grid be your inspirational guide. Some things to consider include how many fingers you want to fit and whether you want to have a thumb or pinky rest. Another thing to consider is balance. Where you place the handle will determine the overall ease in drinking from your vessel. This all depends on your mug shape and where the weight is being distributed. It's also a good idea to leave enough space so your fingers don't touch the wall of the mug (which could potentially be hot).

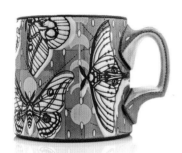
Renee LoPresti

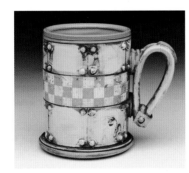
Mike Cinelli

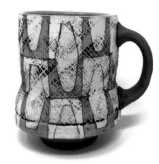
Mark Arnold

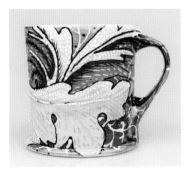
Matthew Schiemann

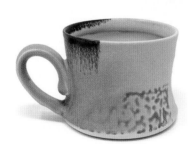
Deb Schwartzkopf

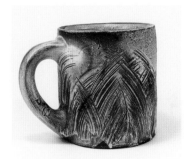
Gillan Doty

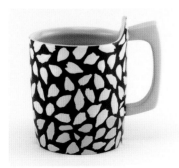
Adrienne Eliades

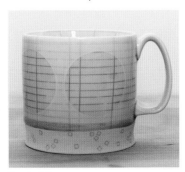
Rachel Donner

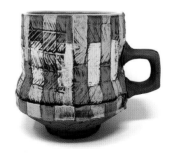
Mark Arnold

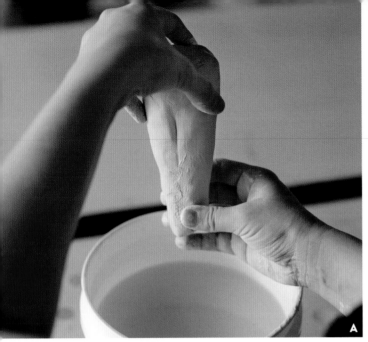

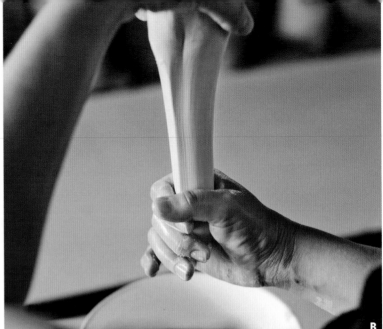

Pulled Handles

Pulling handles is the most traditional way to make handles in clay. It uses the unique imprint of your hand and fingers to produce a handle. This process may seem tricky at first, but if you persist you will find a sweet rhythm. As my professor once said, "After you have pulled a hundred handles, you just might get it." I don't think it takes quite that long to "get it," but maybe to "master it."

STEP 1 Start with 1 to 2 pounds (453 to 907 g) of freshly wedged clay. Pat the clay into a cone shape with your hands. **[A]**

STEP 2 Hold the top of the coned clay with your left hand over a bucket of water and, using your right hand, begin moistening the clay. You can even dunk the whole cone up to your left hand in the water bucket. **[B]**

STEP 3 Wet your right hand and start pulling the clay downward. I have been told this is similar to milking a cow (something I have never done, so I can't relate). What I can tell you is the process becomes easier if you make a crab claw with your right hand during the pulling movement. **[C]** If you want, use your thumb to make an indentation in the clay. **[D]**

TIP *I switch back and forth when using my thumb so as to not create a deep ridge in my handle. However, if this is the effect you want, continue using your thumb more often throughout the movements. For example, thumb, thumb, thumb, crab claw, and repeat.*

STEP 4 With your long pulled piece of clay, cut your handle to size. Rest the end of your cone on the edge of your table and use your X-ACTO knife to cut away the size handle you need. **[E]**

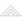

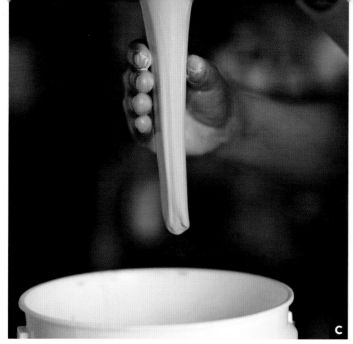

D

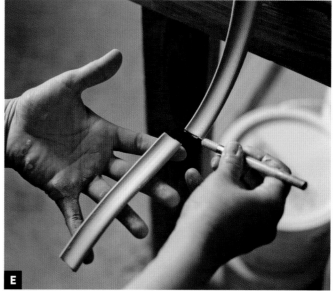

E

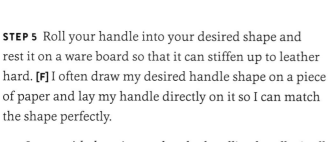

STEP 5 Roll your handle into your desired shape and rest it on a ware board so that it can stiffen up to leather hard. **[F]** I often draw my desired handle shape on a piece of paper and lay my handle directly on it so I can match the shape perfectly.

TIP *Just as with throwing on the wheel, pulling handles is all about even pressure. If you squeeze too hard, the clay will become thin and weak and might break in half mid-pulling. If you don't squeeze hard enough, your handle will grow at a turtle's pace. As with everything in pottery, practice, practice, practice.*

C

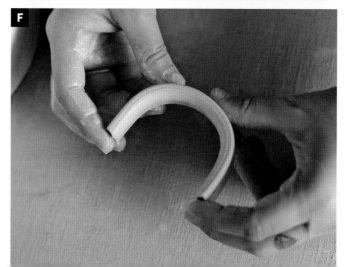

F

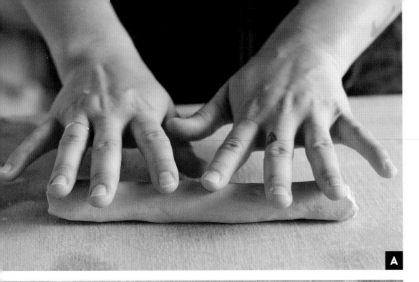

A

Rolled Handles

If you are having trouble finding your groove pulling handles and are looking for some instant success, I highly recommend trying this next technique. Rolling handles is the perfect "fake it until you make it" method. Some students never go back to the pulling method, but both techniques have their time and place.

STEP 1 Grab a ¼ pound (113 g) chunk of fresh clay and pound it into a hot-dog shape using the palms of your hands. Create a thick coil and start rolling. **[A]**

STEP 2 Place your coil hot dog on a nonstick surface such as a canvas-covered table or a ware board. Start rolling your hands over the clay from front to back in a forward to backward motion. **[B]**

TIP *To roll a perfect coil, open and close your fingers during the movements, and move from the center outward and back to center. Avoid keeping your hands stationary for too long or else your coil will look lumpier than it does smooth.*

STEP 3 Continue rolling until your coil is about as wide as a penny or a nickel. The width will depend largely on how big your mug form is. If you have a large-size mug, use a thick handle, or a thin handle for a small mug shape. **[C]**

STEP 4 Starting on one end of the clay, press the coil into a flattened oval shape with your thumb. **[D]** This method can cause a few lumps, so if you are a perfectionist, grab your rolling pin and in one gentle sweep, flatten the coil. **[E]**

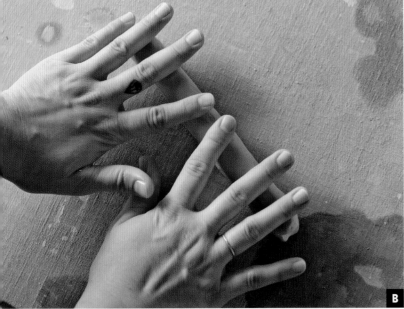

B

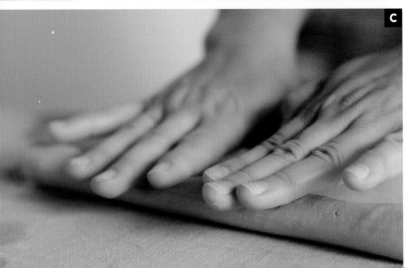

C

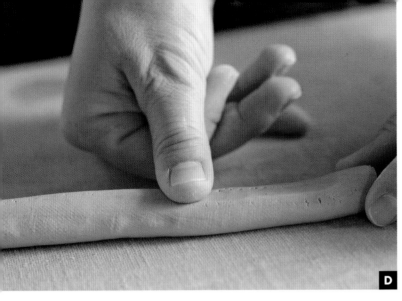

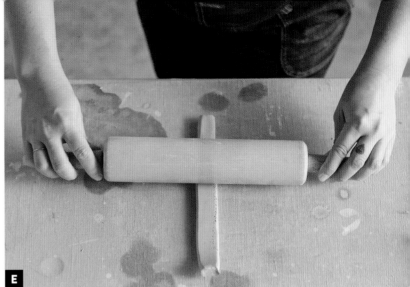

D **E**

STEP 5 The last step in this process is shaping the clay to your handle form. Using the same method as pulled handles, cut your desired handle size and roll into the perfect shape. Let it rest on a ware board to dry and catch up to your leather-hard pot. **[F]**

TIP *If you want this to look like a pulled handle, follow this method before shaping the clay: Grab your flattened coil and hold it just like you were pulling a handle over a bucket of water. Moisten your hands and "pull" the handle a few times to give it a slick shape. This pulling motion is more cosmetic than it is actually pulling the clay. Cut to shape and you're done.*

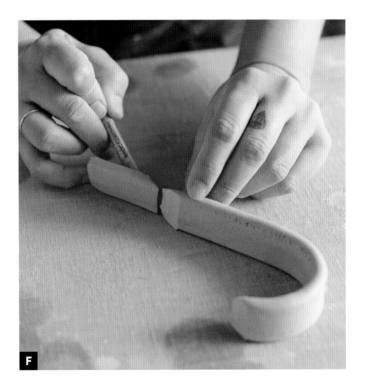

F

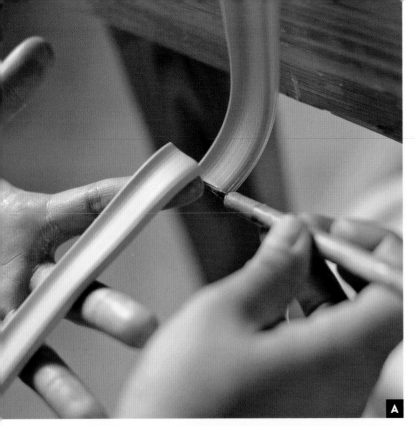

Sliced and Diced Handle

As your skills enhance, you might notice the plethora of more complex handles on hand-crafted mugs. There are more than a couple of ways to make a handle, such as pinching, slab building, slip casting, and hand building. The slice and dice method will open you up to a whole new world of creative opportunity with mugs, making your handles more comfortable, more aesthetically pleasing, and more dynamic.

In this demonstration, I will show you step by step the development of my signature "ear" handle on my Blue Ridge Mountain mug. This handle design started as an idea while I was on a mission to create the most comfortable handle. Once I settled on the mug shape and size, I sketched out my handle design to scale. Using the slice and dice method, this is how I made this handle.

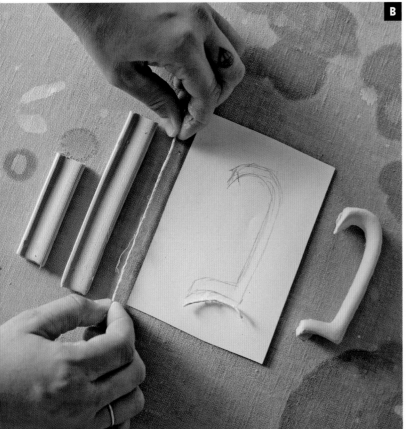

STEP 1 Using the pulled or rolled method, cut one long piece of clay and one short piece of clay. **[A]**

TIP *To determine the size of each piece of clay, I took string, placed it over my drawing, and cut the two sizes I would need.* **[B]** *Give yourself a little extra slack in case you have to cut away more than you think.*

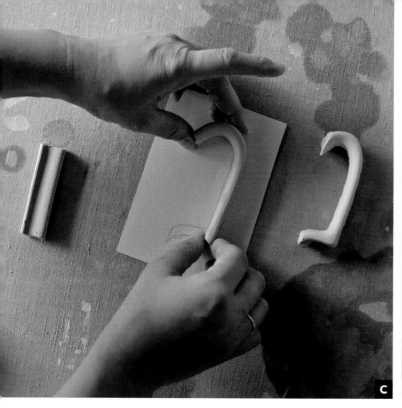

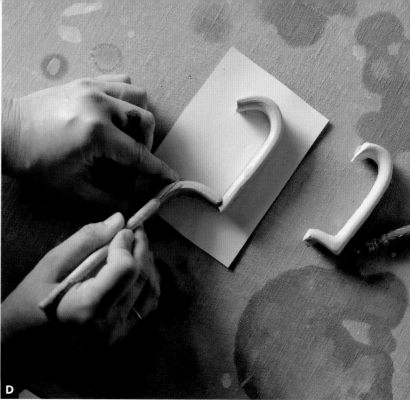

STEP 2 Bend the long piece of clay into shape one and the short piece into shape two. **[C]**

STEP 3 If your clay is ultra moist, let the two pieces stiffen up to just before leather hard. To attach the two pieces, dip your scratchy tool in water and scratch the surface of both connection points. What you are looking for here is a nice slurry of clay to act as the glue that binds the two pieces together.

STEP 4 Attach the two pieces of clay together. Once this step is complete, I typically let my handle sit out for a little bit. This gives the two pieces of clay enough time to bond together and stiffen up just enough to smooth the attachment points. **[D]**

STEP 5 Clean up the handle with refining tools or a paintbrush. As long as your handle is close to leather hard, it is ready to be attached to your pot.

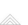

ATTACHING HANDLES

Now for the exciting part: attaching your beautiful handle to your beautiful mug. Decide the placement of your handle based on function first and aesthetic second. Is it comfortable and does it look balanced? I rely mostly on intuition for this part rather than design rules, but if you are a methodical person, there are plenty of resources for diving deep into composition using a mathematical approach.

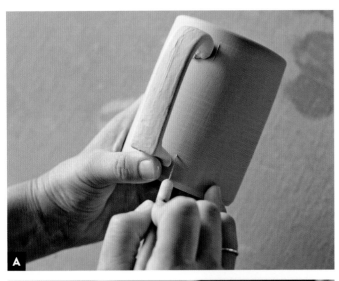

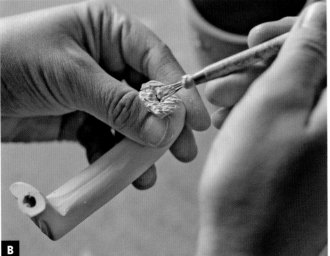

TOOLS AND MATERIALS

X-ACTO knife
needle tool
scratchy tool
smoothing tool
mug
handle
bucket of water
sponge

Instructions

STEP 1 Decide on the placement of your handle by holding it up to your mug. Use your needle tool to mark the connection points on your mug. **[A]** If the connection points of your handle do not perfectly match up to your mug, use an X-ACTO knife or a surform tool to gently round the connection points.

STEP 2 Dip your scratchy tool in water and scratch the surface of the marked areas on your mug. Do the same with the attachment points on your handle. Just as with the slice and dice method of scratching, you want to create a slurry of clay at your attachment points to serve as a glue. **[B]**

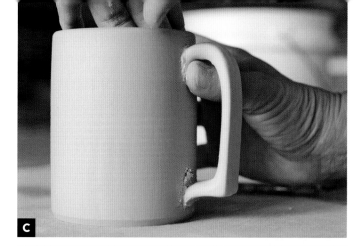

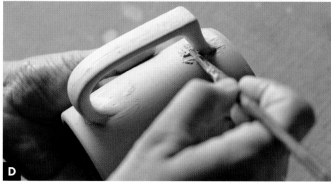

What happens if my handle cracks or pops off? Most potters would scrap the clay and start over, but when you're a beginner this might leave you feeling defeated. Thanks to advancements in clay there's a miracle product called Axner Fix-It! It can be applied to greenware but works best on bisque. Simply work it into cracks and smooth over with a rib, or attach broken handles with a paintbrush. While I recommend getting to the root of your cracking issues by working on drying time and attachment, this product works wonders.

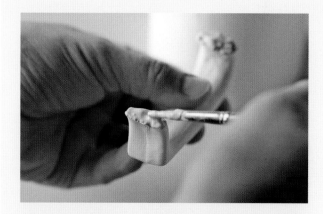

STEP 3 Attach the handle. This is truly the best part of the mug making process when your vision comes to fruition. Hold your handle with your left hand and gently press it into the connection points. Use your right hand on the inside of your mug so that you are pushing the mug into the handle and the handle into your mug. This will help you avoid misshaping your mug. Check the handle from all angles before you get comfortable merging the two completely. I often put my handles on crooked, so it's good to check this before you get carried away. **[C]**

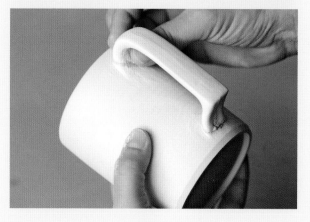

STEP 4 Once your handle is attached to your mug, begin the last step of smoothing. There are several tools to aid you in this venture. I use a combination of smoothing tools and paintbrushes to achieve this last bit of perfection. **[D]** Congratulations, you just made your first mug!

UNDERSTANDING CLAY AND TRIMMING

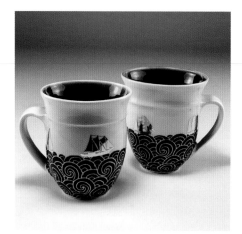

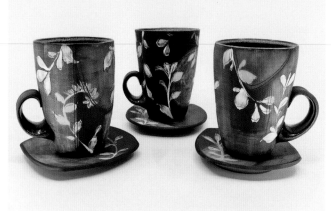

Anja Bartels, Golden Sailing Ship Mugs
Wheel-thrown porcelain, fired to cone 7 electric, sgraffito decor, gold decals

Heather Spontak, Teacups and Saucers Wheel-thrown black clay with colored terra sigillata, slip, sgraffito, cone 5 oxidation

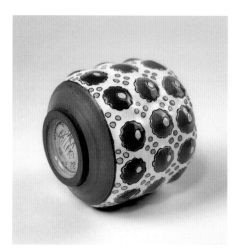

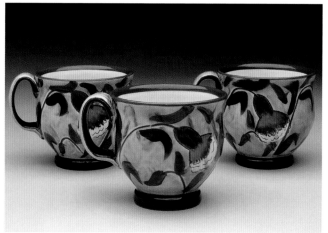

Sara Ballek, Bubbly Cup Bottom

Bottoms up! This cup has been trimmed with purpose so the artist has room to sign the foot without compromising the contact it will make with any surface.

Ben Carter, Three Blue Mugs

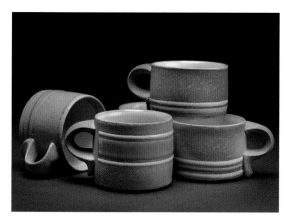

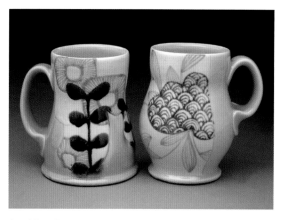

Austin Riddle, Mugs Soda-fired porcelain, cone 11
Photo courtesy of Robert Batey

Jen Allen, Two Mugs Wheel-thrown porcelain

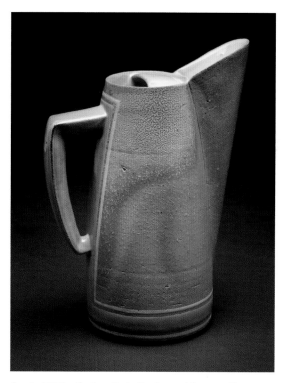

Deb Schwartzkopf, Cup Wheel-thrown and hand-built porcelain, cone 6 electric with underglaze dots

Austin Riddle, Pitcher Soda-fired porcelain, cone 11
Photo courtesy of Robert Batey

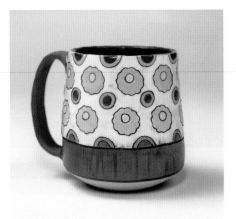

Renee LoPresti, Mug Wheel-thrown 2020 stoneware underglazes, glazes, and luster, fired to cone 5 and 019 electric oxidation

Sara Ballek, Mug

Sara uses a variety of techniques from chapter 4. Two layers of white slip cover the earthen red clay, and patterns are created using the sgraffito technique. Color has been meticulously painted with underglaze.

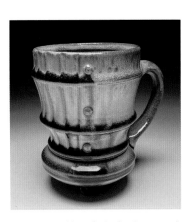

Luke Doyle, Mug Soda-fired in a wood kiln to cone 12

Meredith Host, Dot Dot Rounded Square Mug

Mike Cinelli, Mug

Slip Casting

⌃⌃⌃

Slip casting is the technique of pouring liquid clay into a mold (most commonly plaster) to make duplicate forms in ceramics. They can be complex or simple. When it comes to handles, most potters can get by using two-part molds. These can be very elementary in execution or more advanced based on modern technology and skill level. Below Shannon Tovey, mold maker, explains how a simple handle form turns into a prototype.

Using 3D printing within my slip-casting process allows me to create resin models that will withstand the mold-making process and remain workable for future use. When models are made out of clay or plaster, they can often get damaged during the mold-making process, making it harder to replicate the same form again if need be. To begin each project, I build a 3D drawing of the product I am going to create in a computer software called Rhinoceros. This software is so precise it allows me to work within fractions of a millimeter to ensure I can achieve the right detail or size of a piece. Once I have the product file built correctly to scale, I will get it 3D SLA printed in standard resin so it can be checked in person for size and form. If I approve the prototype, I then go back into Rhino, scale the whole piece up between 10 and 15 percent to account for the clay's shrinkage during the firing processes, and get it printed again. This enlarged version is the model that I make the mold from.

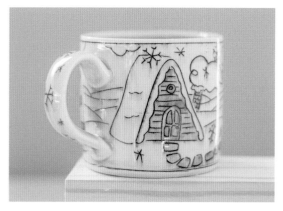

Laurie Caffery, Cabin Mug Porcelain, underglaze and mishima, cone 6 oxidation

Shannon Tovey, Handle Model (middle) Mold (bottom) for Laurie Caffery Mug
Photo courtesy of Laurie Caffery

Teamwork makes the dream work. Shannon made this mold by casting the "master" handle created by Laurie.

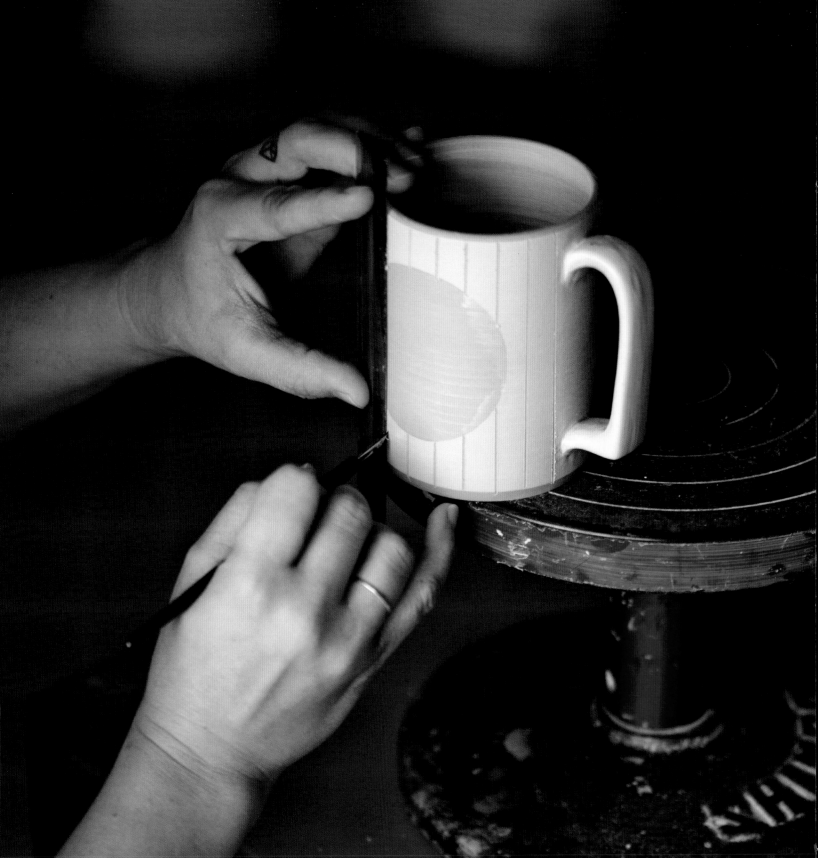

4
SURFACE DECORATION

Once you find success in throwing, trimming, and creating more advanced forms, you might find yourself thinking about surface decoration. There are *so many* ways to transform the surface of your pottery to reflect your own personality. I believe this is when a budding potter's creativity truly comes to life.

In this chapter, I will share a plethora of surface techniques that you can apply to achieve your own personal aesthetic, from creating raised surfaces with liquid clay to using underglazes and stencils. If you love drawing, painting, patterns, or color, this is your time to shine. After reading this chapter, you might not be able to leave your pot bare ever again.

IMPORTANT NOTE: *Inspiration for the surface of pottery often starts by viewing the work of established artists. While it's acceptable to gain inspiration and knowledge from others, it is important to adopt the technique in your own special way. For example, instead of directly copying a stencil design or a floral motif from another artist, think about what inspires you personally and how you can use that technique to reflect you. So how do you gain inspiration for yourself? I recommend creating an inspiration board. Collect magazine clippings, photographs, drawings, and fabrics to help you start thinking about what designs and color combinations make you sing. I promise you will find your way.*

MIXING A SLIP

Mixing a slip or following a recipe in clay is very much like baking. The ingredients have to be measured with precision in order for the slip, glaze, or cookie to turn out as desired. Therefore, it is important to use a scale that is 100 percent accurate and to be free of distractions when adding materials. Before you get started, you must be sure you are in a well-ventilated space and wearing your respirator. Dry materials kick up dust particles in the air, which are unhealthy to breathe in. Following the recipe below, it's time to mix some slip.

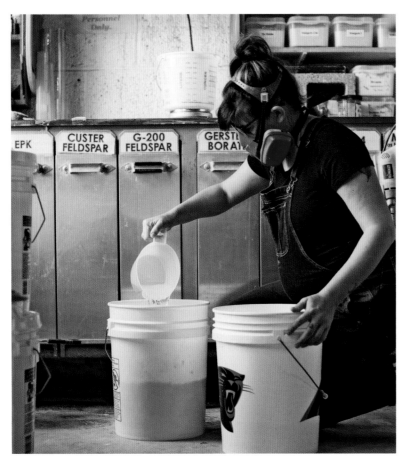

All-Purpose White Slip

MATERIALS

EPK	28
OM4	28
Silica	22
Frit 3124	22
	100

COLORANTS

Zircopax 5 (white colorant)
Mason Stain 6 to 10 percent depending on
 the vivacity of color you want. Test, test, test.

NOTES: *Most recipes measure to 100 grams. Determining batch size depends on how much you need. I recommend starting small to test slips and colors on your clay body before you dive into a big batch. For a painting-size amount, 200 to 500 grams is sufficient. To fill a 5-gallon bucket, 5,000 grams is appropriate.*

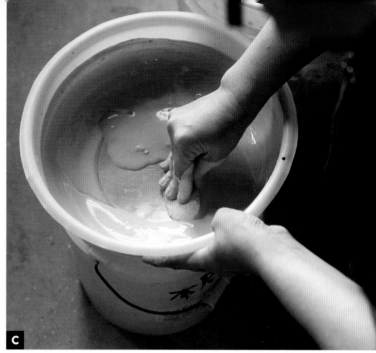

TOOLS AND MATERIALS

scale

1 small bucket

2 large buckets

mesh sieve

hard rib

respirator

materials listed

water

pitcher

mixing drill

writing utensil

spatula or stir stick

Instructions

STEP 1 Before you dive into weighing out materials, it is important to get set up first. Have your scale out and ready with a small bucket for weighing and a larger bucket for adding and mixing. Have your recipe and a writing utensil handy to cross off or check mark materials as you add them.

STEP 2 Set your scale to grams and place your small bucket on the scale. Press tare. This is to set the scale to zero so the bucket is not included in the weight of the material.

STEP 3 Weigh out materials one by one. Remember to check off each material as you add it to the larger bucket. This may seem like a given, but trust me, if you get distracted or lose your place, it might be hard to tell where you left off because most dry materials look the same.

STEP 4 After adding all materials to the bucket, slowly add a little water at a time. Mix manually at first with a spatula or stir stick. **[A]** Once your slip starts to resemble spoiled

milk, come in with your power mixer and start mixing. The power mixer will break up chunky particles so the slip will start to resemble pancake batter. Keep adding water until you reach the consistency of buttermilk. **[B]**

STEP 5 Now that your slip is pretty well mixed, it is time to sieve it. The sieve will break up any remaining chunks and ensure your slip is a smooth consistency. I recommend using a 100-mesh sieve for slip. Get your second large bucket ready and place the sieve over the bucket. Start pouring the slip into the sieve. Once it is almost full, stop to work the material through the sieve. I use a hard rib for this. **[C]**

STEP 6 After all the slip has passed through the sieve, it is ready for use. I recommend letting it sit for a while because the particles continue absorbing moisture as the slip settles. You may find you need to add water and mix again before use. Congratulations, you just followed your first clay recipe.

SLIP PAINTING

When potters use the word *slip*, they are referring to liquid clay. As with everything in ceramics, there is no one standard slip. There are slips formulated for decorating the surface of clay, and there are slips for casting clay to be used in mold making. Slip decoration requires a slip recipe that closely matches the type of clay you are using. Otherwise it might not fit right, meaning it could pop off, crack off, or cause problems in the glaze firing.

One of the easiest ways to transform the surface and color of your pottery is by adding slip. Slip can be used in a painterly way or it can be more calculated in its application. Most commonly, white slip is used over a red clay surface or for the purpose of promoting flashing in atmospheric pots, but slip can be made in multiple colors using stains and oxides.

So why slip and not underglaze? One reason career potters prefer slip to underglaze is because it is relatively inexpensive to make in comparison and yields bigger batches. To mix your own colored clay slip, follow the recipe and instructions on page 94. Slip painting can be done freehand or on the wheel; this will depend on your specific pot.

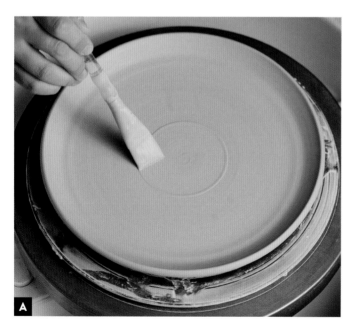

A

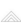

TOOLS AND MATERIALS

slip
paintbrush
leather-hard pot
wheel
wet clay or Giffin Grip
rib

Instructions

STEP 1 Secure your pot to the wheel using lugs or a Giffin Grip.

TIP *If you are slip painting a plate, leave it on the bat until it stiffens up a bit. That way all you have to do is place it on the wheel with bat pins and it's already centered and secure.*

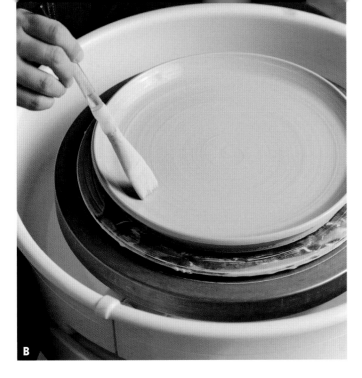

STEP 2 Thoroughly mix your slip. Dip your paintbrush in and give it a go. Start with something as simple as a swirl. **[A]** Wheel speed and how fast you are moving your paintbrush outward will determine the tightness of the design. **[B]**

STEP 3 You can go further and cover your whole pot in slip, then work subtractively to create a swirl. Cover the whole pot evenly with slip, then use your finger or a rib to subtract clay while the wheel is spinning. **[C] [D]**

TIP *Try different movements with your rib. The best way to discover your own personal aesthetic is to play around; introduce another colored slip over your first layer to create more variation in color.*

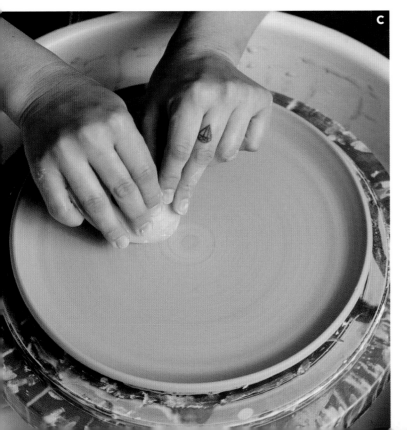

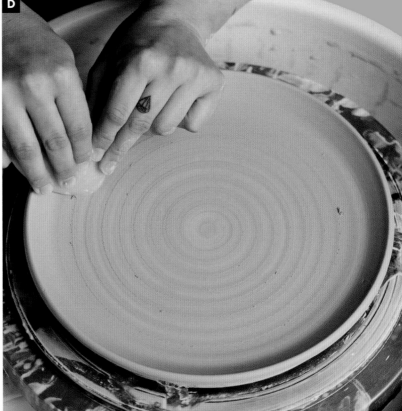

SLIP DIPPING FOR CARVING

Slip is often used in conjunction with carving. The contrast of a colored clay slip over a clay surface when carved through can be pleasing to the eye. In this process, you can freehand, wheel apply, or use the dipping method. The technique you use will depend on your personal aesthetic. If you want to avoid brush marks or the possibility of uneven application, I recommend dipping. Use a bigger batch of slip to make this process easier.

TOOLS AND MATERIALS

slip
water
mixing drill
firm leather-hard pot
carving tool

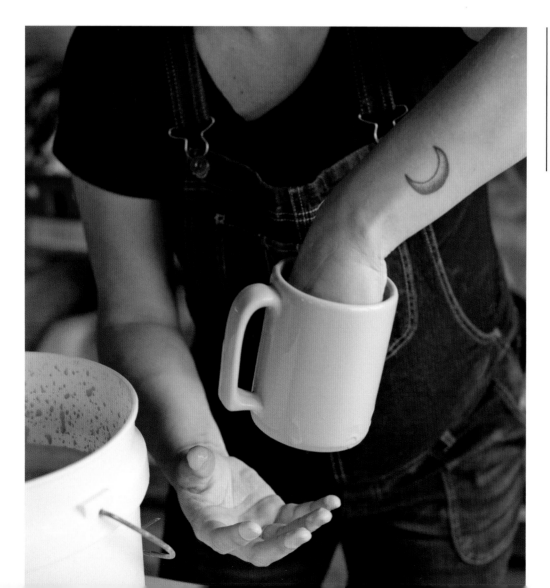

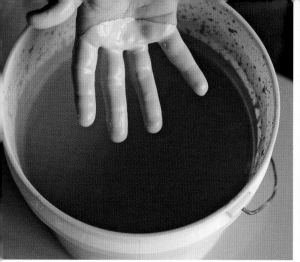
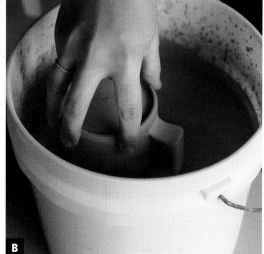
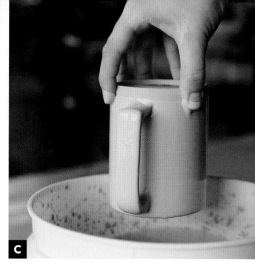

Instructions

STEP 1 To make your slip the right consistency for dipping, add water. Do this gradually, as the only way to thicken it back up if you add too much is to leave it uncovered so moisture evaporates or to add more dry mix. Slowly add water and mix well.

STEP 2 When your slip reaches the consistency of buttermilk, it is ready for dipping. To test this, I like to use my hand. If I can see through the slip, I unfortunately added too much water. If it looks like a nice thin, milky coating, then it is ready. **[A]**

STEP 3 Time to dip. Grab your pot and dip it into your slip. Then carefully set the pot down on your ware board. **[B] [C]**

STEP 4 Allow your pot to dry to leather hard again before handling. Keep in mind that when you add slip to leather-hard clay, you are reintroducing moisture. This will soften the pot back to a plastic/wet state. Depending on the humidity, this could take several hours or more to dry.

STEP 5 Once your pot is no longer tacky to the touch, you are ready to carve. This could be something as simple as lines or a full-blown drawing. The sky is the limit. Happy carving! **[D]**

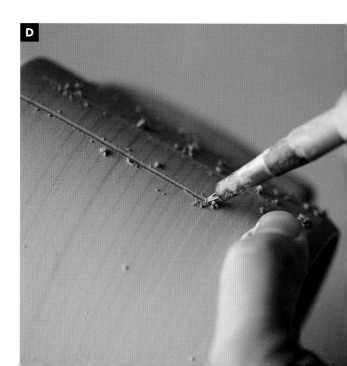

UNDERGLAZE: USING STENCILS

If you are a beginner and do not want to mess with dry materials or mixing slips, premade underglaze is the way to go. Several companies sell underglazes that come in an array of colors. Underglaze comes in the form of crayons, pencils, watercolors, or paint. Underglaze painting can be done freehand, on the wheel, in conjunction with stencils, inside carved lines, and even transferred from newsprint. The sky is truly the limit.

Stencils are a fabulous way to transform the surface of your clay. They can be simple or complex. A number of materials can be used to make stencils, including paper, vinyl, Tyvek, and even a leaf. Paper and vinyl stencils are the easiest to apply, but they can be used only once. The building material Tyvek can be used multiple times and can withstand a substantial amount of use. To visually plan for stencils, keep in mind that the shape or design you choose will be the color of the clay, unless you are layering multiple colors. I find it useful to get out my colored pencils and sketch out ideas first for a design and surface area for the stencil.

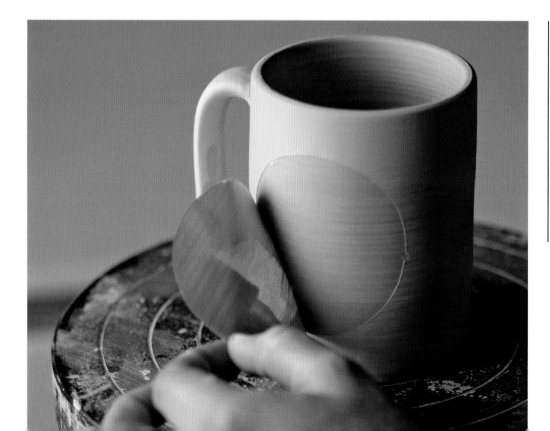

TOOLS AND MATERIALS

pencil or marker

Tyvek

scissors

banding wheel

decorating disk

paintbrush

bucket of water

sponge

medium rib

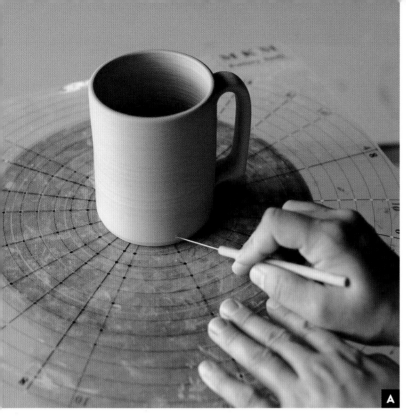
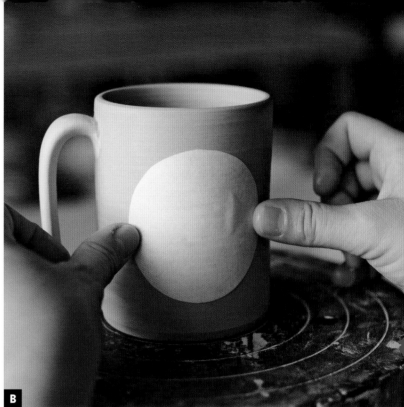

Instructions

STEP 1 Starting with a leather-hard mug, map out the size of your stencil. You can use found objects such as cups, a compass, a rough sketch, or something a little fancier such as a circle grid.

STEP 2 Next, trace the circle on paper or your preferred material.

STEP 3 Cut the circle out. If you are using Tyvek or vinyl, be sure to use sharp scissors. If you choose something with straight lines, I recommend using an X-ACTO knife and a ruler.

STEP 4 Now that you have your stencils cut out, it's time to decide where to place them on the pot. Do this by "eyeing it up" or by mapping out the stencil placement using a decorating disk. Since I want my circle window to be on both sides of the mug, I will use my decorating disk to mark equal parts of the clay. **[A]**

STEP 5 Next, submerge your stencil in water and place it on your pot. I find it helpful to shake off some of the excess water so I don't create a puddle at the foot of my pot. **[B]**

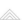

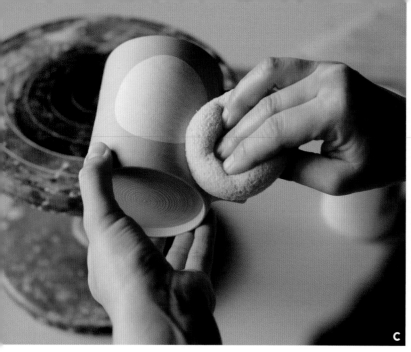

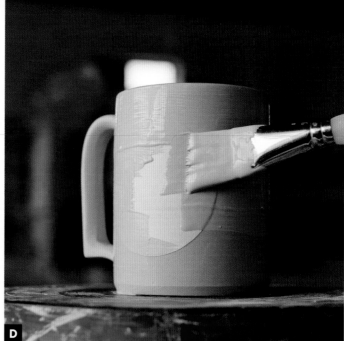

C D

STEP 6 Gently smooth over the stencil with your clean sponge. If you are using Tyvek, use a rib to secure the edges to the pot. **[C]**

STEP 7 Now you are ready to paint over your stencil. Choose a suitable brush that provides smooth strokes (if that is what you are going for). In my experience, underglaze usually takes three coats to create an opaque layer of color. Or, you may want transparency. I recommend testing a range of layers of paint on random tiles before you dive into painting your whole pot, as all underglazes are different. One brand may be thicker than another. **[D]**

TIP *Let each layer of underglaze dry between coats. If you paint over wet underglaze, chances are it will smear off or smudge into the layer of clay underneath. It is dry when the underglaze is no longer shiny. Test it by touching the underglaze with your finger. If it leaves a fingerprint mark, it is too wet.*

STEP 8 Now the exciting part, removing the stencil. If you leave the stencil on long enough, it will start to peel off on its own as it dries. If you are impatient like me, use your X-ACTO knife or any sharp object to lift the stencil off your pot.

TIP *If you are using a stencil on a round object such as a plate, make it easier on yourself and secure your plate to the wheel to paint the underglaze. The same tip goes for removing underglaze from unwanted areas. Once the underglaze is completely dry on my mug, I put it back on the wheel and use a trimming tool to clean up the top and bottom.*

UNDERGLAZE: TRANSFERS

If hand-painting, drawing, or carving isn't your forte, there is still so much to explore. Underglaze transfers are a great way to add flawless patterns and designs to your work. They are easy to make yourself and even easier to purchase commercially. Newsprint transfers are specifically for use on leather-hard clay. The unique advantage to using newsprint transfers is that you can add more color to them by using underglazes.

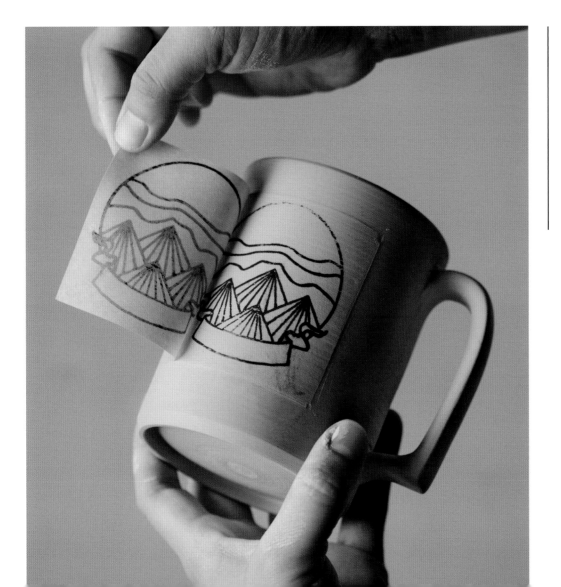

TOOLS AND MATERIALS

newsprint transfer
underglaze
paintbrush
spray bottle
sponge
bucket of water
soft rib
leather-hard pot

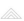

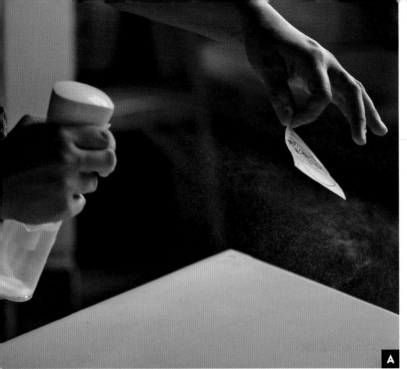

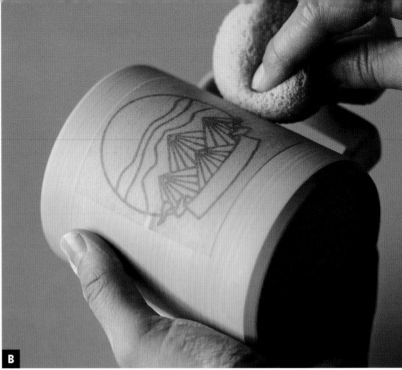

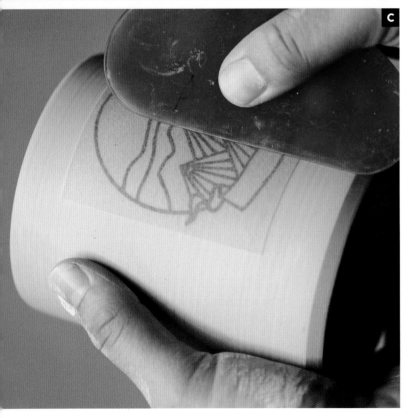

Instructions

STEP 1 Optional: To add color to your newsprint transfer, start with the printed side up and get painting. Keep in mind that the layer you are painting will be *underneath* the first layer of the newsprint once applied.

STEP 2 After your added underglaze has dried, you are ready for the application process. First, determine placement and decide whether you need to cut the image to match the size of your pot.

STEP 3 Using your mist spray bottle, generously mist the back of your newsprint. Do the same with the front side. **[A]**

STEP 4 When your newsprint is no longer shiny but has absorbed the water, place the printed side down on your piece. With a moist sponge, make sure the newsprint has made contact with all areas of the surface. **[B]**

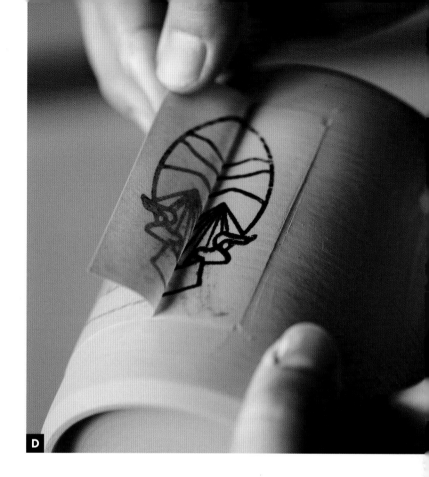

D

STEP 5 Use your soft rib to work the back of the newsprint, ensuring that the underglaze is lifting off the paper and onto your pot. **[C]**

STEP 6 To check if you need to continue ribbing or add more moisture, gently peel back the edge of your newsprint. If you are looking for a flawless and crisp image transfer, you may need to keep ribbing. If you are more interested in a "distressed" look, you can stop ribbing sooner. **[D]**

STEP 7 Once you are happy with the quality of the image, gently peel off your newsprint completely. Now wasn't that fun?

Troubleshooting

Why aren't my lines crisp or distressed, and instead are bleeding and smudged? Ah yes, you either used too much water or you did not wait long enough to apply your transfer. This is a time-sensitive process, so if you don't get it right the first time, keep trying. I would recommend rolling out clay slabs and experimenting with consistency and technique before you try it on your favorite piece.

SGRAFFITO

Sgraffito derives from the Italian word meaning "to scratch." In this technique, a layer of color is applied to the surface of a pot. This is usually done at bone dry. Then a design is carved through the colored layer, revealing the bare clay underneath. The contrast of the bare clay as seen through the carved colored surface is not only visually pleasing but also offers a subtle element of texture. When using this technique, wear your respirator because the dry clay is not safe to inhale. I also recommend doing this outdoors or under some sort of ventilation. When using this technique indoors, use a wet sponge to clean up any dust particles left behind.

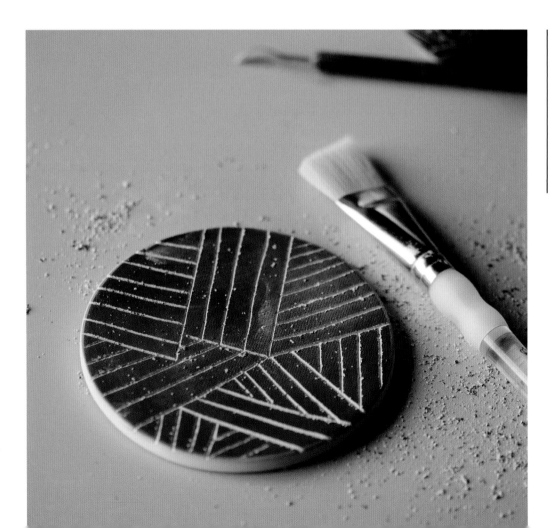

TOOLS AND MATERIALS

bone-dry pot
underglaze
paintbrush
dry brush
scratching tool
respirator

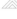

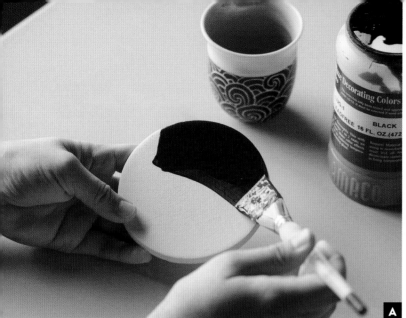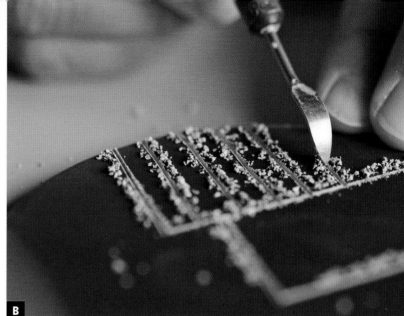

A **B**

Instructions

STEP 1 Paint the bone-dry surface of your pot with under-glaze. I recommend using a darker color that will contrast nicely with the color of your clay body. **[A]**

STEP 2 After the underglaze is dry, begin scratching. As with all surface decoration techniques, it is beneficial to have a design ready before you dive in. You can freehand or follow a stencil design, whatever your heart desires. **[B]**

STEP 3 Continue scratching until you are happy with your image. **[C]** If you are working indoors, use a dry paintbrush to remove the dust off your carvings rather than removing your mask to blow it off.

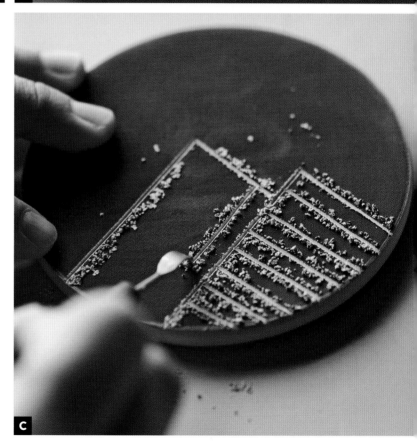

C

MISHIMA

Mishima refers to the technique of inlaying a colored slip or underglaze into carved lines in clay. It is a two-part process: carving and then inlaying the color. Carving is typically done at leather hard, while inlaying the color is best done at bone dry. To carve your pot, use tools specifically made for mishima, an X-ACTO knife, or a found object such as a stylus (my favorite tool). Carving can be done with or without the use of wax resist. How to choose? If you are carving onto a bare surface, you don't necessarily need the wax, but if you are carving over a decorated surface, wax is useful so you don't erase what has already been done. This will make more sense as you learn the technique. Let's dive in.

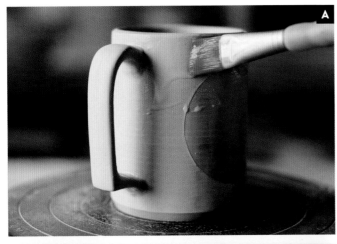

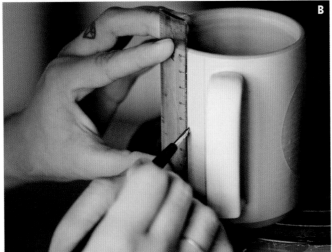

TOOLS AND MATERIALS

wax resist

paintbrush

carving tool

banding wheel

underglaze

hard bristle brush or toothbrush

sponge

Instructions

STEP 1 Starting with a leather-hard already underglazed pot, paint the wax resist on the surface area you intend to carve. **[A]**

TIP *I wax a little further down and get it into any crevices that might easily pick up my inlay color.*

STEP 2 Once the wax is completely dry to the touch, you can carve into the clay. Depending on the aesthetic you want to achieve, you can carve freehand or with a ruler or guide. **[B]**

C

D

E

F

TIP *I love using old business cards in place of rulers. They bend with the shape of my clay and are easier to hold onto at times.*

STEP 3 Carve, carve, carve. **[C]**

STEP 4 Once you are done carving your pot, it is important to let it dry to bone dry. I know it is tempting to dive right in and paint those lines, but I promise you will have more success getting that inlay color to stay and really pop at bone dry. Also easier at bone dry is removing the burrs left behind from your carving tool. To do this, use a hard bristle paintbrush or my favorite alternative, a toothbrush. Give it a quick scrub. **[D]**

STEP 5 Next, paint the inlay color. Give the paint a stir or a shake, then paint the inlay color over your carved lines. You may have to angle your paintbrush to get into some of the grooves. Another way to get your underglaze into every line is to water it down a bit, as it may be too thick. **[E]**

STEP 6 Paint your entire pot, then start wiping. At this stage you can already see the work the wax is doing by resisting the underglaze in all the areas except where I have carved. Using a clean sponge and bucket of fresh water, start wiping the surface of your pot. You may have to rinse the sponge and wipe a few more times to achieve perfection. **[F]**

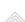

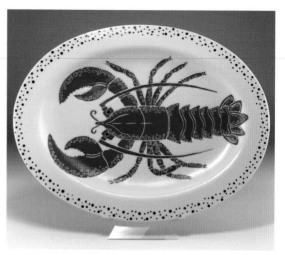

Anja Bartels, Sea Urchin Bowl Wheel-thrown porcelain, fired to cone 7 electric, slip trailing decor, three layered glazes on interior

Anja Bartels, Lobster Platter Sgraffito, fired to cone 7 electric

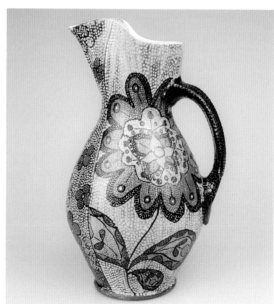

Gillan Doty, Plate Wood-fired

Matthew Schiemann

Austin Riddle, Creamers Soda-fired porcelain, cone 11

Sara Ballek, Shallow Bowl

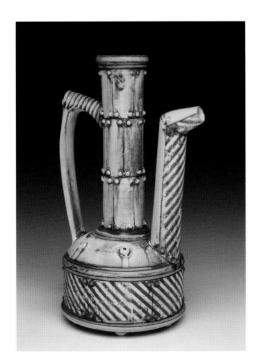

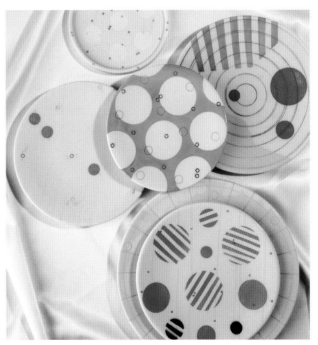

Mike Cinelli, Ewer

Rachel Donner, Plates
Photo courtesy of Emily Mason

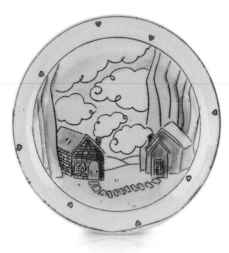

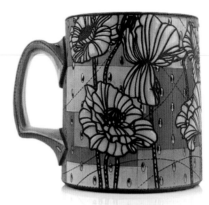

Laurie Caffery, Cabin Side Plate Porcelain, underglaze and mishima, cone 6 oxidation

Laurie carves her mishima lines at leather hard and then waits until bone dry to fill the lines and wipe. This allows her to smooth the burrs left by her carving tool. After bisque she uses watered-down underglazes to "watercolor" her illustrations.

Renee LoPresti, Mug Wheel-thrown 2020 stoneware underglazes, glazes, and luster, fired to cone 5 and 019 electric oxidation

I fell in love with Renee's work years ago. Her layered surfaces and color palettes continue to impress me. I had been hand-cutting my stencils up until I watched a demonstration of her process. Renee uses a die cutter to cut vinyl stencils—so simple but brilliant.

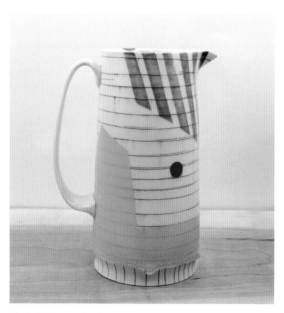

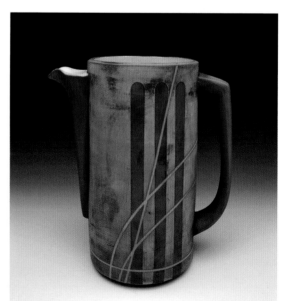

Rachel Donner, Pitcher

Eric Heerspink, Pitcher

Adrienne Eliades, Plate Front and Back
Porcelain hand built, underglaze and
glaze decoration, fired to cone 7 oxidation
Photo by artist

Adrienne Eliades, Teapot Wheel-thrown with hand-built lid and
handle, underglaze and glaze decoration, fired to cone 7 oxidation

Liana Agnew, Plate

Gabriel Kline, Rice Bowl Cone 7

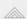

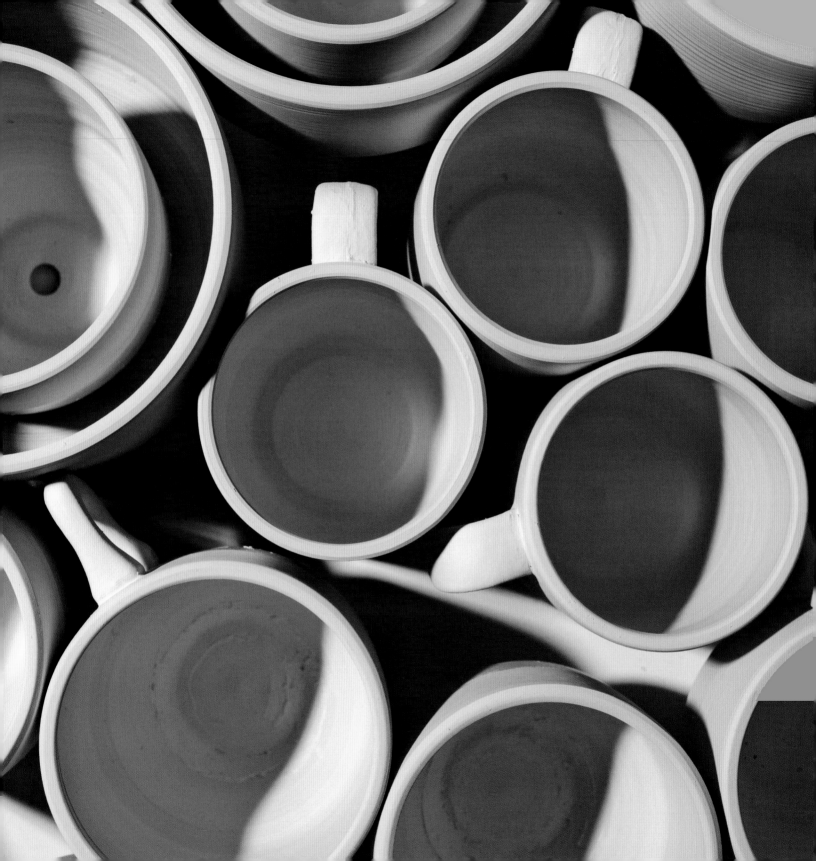

5

GLAZING
AND FIRING

Firing your work is often the last step in pottery making, yet it can be the most crucial. For new potters, firing can be a make or (literally) break moment! In this chapter, we will cover the basics of the bisque fire, then get into glaze. While you will need to take a workshop or buy another book if you have never glazed before, it is important to learn the basics. I have included a few fundamentals in this book. Once you get the hang of it and gain a certain amount of comfort, you can begin to develop your own personal aesthetic. If you want access to a variety of glazes, I recommend joining a community clay studio or taking an advanced workshop.

LOADING AND FIRING A BISQUE KILN

If you are taking pottery classes in a community clay setting, it is likely that you will not be involved in the firing process unless you volunteer to learn and assist. Nonetheless, it is helpful to understand the basics of what goes on in the kiln. Bisque firing refers to the first firing that your pottery will undergo. This happens when you are completely finished with the wet portion of making and decorating your piece. How do you know whether your pots are ready to be bisque fired? It is once they are *completely* dry—which means bone dry. A good way to test this is by holding the pot up to your face. If it is cool to the touch, it may need to dry a little bit more.

TIP *When transporting bone-dry work, always use two hands. If you grab your pot by the rim, it will likely crack. And never grab greenware by the handle!*

If you enjoy puzzles, then you will love loading kilns. Loading a kiln may seem like a scary task at first, but if you follow these simple instructions, you have nothing to fear. First things first: Before I load, I check that the bottoms of my pots are smooth and have not been scratched up during transport. If any of your pots need attention, use a wet sponge to smooth over the abrasions. To start the planning process, organize your pots by height. This is essential to make the most out of the room you have in your kiln. Also take the time to layer pots that can be stacked. For example, a small bowl can be bisque fired inside a larger bowl. There are so many creative ways to load a bisque kiln via stacking.

Loading a Bisque Kiln

STEP 1 Place four small stilts on the floor of the kiln. It is good to have a little bit of lift underneath the bottom kiln shelves to allow heat and air to flow under evenly. Also, some kilns are ventilated from the bottom, so you don't want to plug up the vent holes.

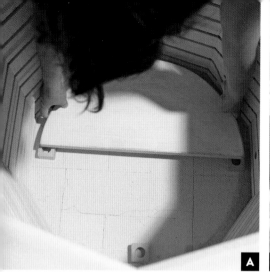

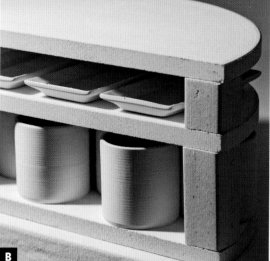

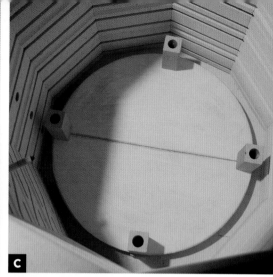

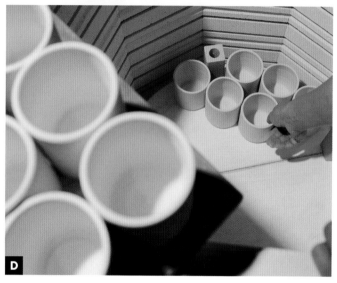

STEP 2 Place the first kiln shelf in the kiln. Both ends should only be covering half of the stilt. This is because the other shelf will share. Sharing stilts at connection points isn't necessary but it is a space saver. (You could easily have six stilts at the bottom of the kiln, but keep in mind you might need more stilts.) **[A]**

STEP 3 Place another kiln shelf on the other side.

STEP 4 Next, determine what you will load first. I recommend not placing anything lower than 4" (10 cm) from the bottom shelf. If you load plates at the bottom of your kiln, you run the risk of underfiring them, as there are no heating elements in the very bottom of the kiln. Next, find four matching kiln stilts closest to that size, making sure they are at least ½" (1.27 cm) taller than your pots. **[B]**

STEP 5 Place the stilts in the kiln in the same placement as the bottom stilts. **[C]**

STEP 6 Load your pots. Since there is no melting involved in bisque firing, your pots can be as snug as you want and touching. Just remember to handle them with care. **[D]**

TIP *Most kilns have a thermocouple, which measures the temperature in a digital kiln. When loading, be aware of the thermocouple and make sure that no shelves are resting directly on it or pots too close to it. It needs a little space for the most accurate reading.*

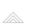

STEP 7 Once your first layer is loaded, add another layer of shelves and repeat steps 2 to 6 until you have a full kiln. **[E]**

TIP *Before you close your kiln to program it or begin firing, follow this simple trick so that no pots are taller than the threshold. Place a long ruler or dowel over the top. If no pots are touching it, then you are good.* **[F]**

Firing a Bisque Kiln

To program your kiln, follow the instructions in your kiln manual. All kiln manufacturers are different, so it is very important that you follow the instructions specific to the model of kiln you are using.

Before programming your kiln, plug all peepholes and make sure the kiln vent is on. Ventilation is not covered in this book, but it is absolutely necessary for safety reasons.

Good luck and happy bisquing!

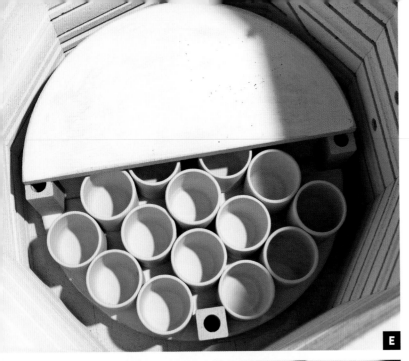

E

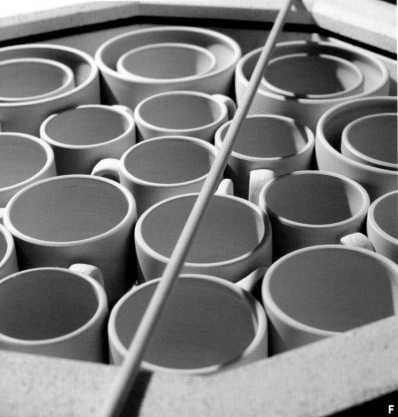

F

What's Going on in There?

More important than learning how to program a kiln is understanding what is happening to your clay as the temperature increases. The purpose of bisque firing is to burn out the chemical water in your clay to make it porous to accept a glaze, but many other things are happening too. As a rule of thumb, bisque kilns should be fired slowly to allow moisture to escape from the pot. Water boils at 212°F (100°C), so if you fire too quickly, you run the risk of exploding your pot! If this happens to you, don't be hard on yourself. It has happened to every potter at least once.

UNDERSTANDING GLAZE

After the bisque firing, it's time to get glazing! Glazes are formulated to the temperature and atmosphere in which you are firing. A glaze recipe consists of several ingredients that are meticulously mixed together to form the perfect combination.

So, what is a glaze then? Glaze consists of three main ingredients: silica, flux, and alumina. Silica is the main ingredient in glass. It can be obtained naturally in the form of sand, quartz, sandstone, or flint. It melts at an extremely high temperature, above 3000°F (1650°C), which is higher than most clays and kilns can fire. That means a flux must be added to a glaze recipe. Flux lowers the melting point of silica and comes in the form of sodium, potassium, lithium, and magnesium, just to name a few. The last main ingredient necessary to make a well-rounded glaze is the refractory agent alumina. Alumina is a primary component in clay that is used in glaze to keep it in suspension.

These three ingredients are often referred to a "base glaze" and are formulated in a ratio that represents unity—meaning all the parts work together to melt at your specific firing temperature. Most glaze recipes also contain additives, known as colorants or opacifiers, that work to change the color of the glaze or alter how opaque it will be.

Firing Temperatures

In most communal studios, you will be working with clay and glazes in the low-fire or midrange temperature ranges and fired in an oxidation atmosphere. Just remember that you are locked in to the specific temperature range of your clay. You cannot try wood firing with your low-fire clay.

Firing Types (from Low to High)

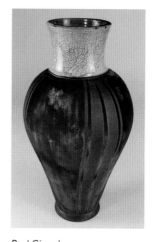

Paul Gisondo

RAKU – An ancient Japanese firing technique. Pots are removed from the kiln with special tongs when they are red hot and placed in a combustible material, typically sawdust or newspaper, in a metal bin or a pit that can be covered. The idea is to starve the pot of oxygen, which at the molten stage gives the glaze a nice variety of colors that can't be achieved any other way. If you love instant gratification, this technique is a one-day firing. There's no waiting for the kiln to cool, and pots are typically fired in a specially made pulley kiln fueled by propane. *Cone 08 – Cone 06*

MAJOLICA – A deeply rooted historical technique of painting glaze materials overtop white-glazed earthenware clay. Typically a white tin-based glaze is painted or dipped after bisque firing, then stains and glazes are painted directly overtop. The pot is then fired to a low temperature in an electric kiln. This technique creates colorful and vivid decoration. *Cone 04 – Cone 03*

OXIDATION – The most common and accessible method of firing in an electric kiln. The electric kiln has sufficient oxygen in the atmosphere, allowing for complete combustion. Due to this method's popularity for glaze firing pottery, there is a plethora of glaze recipes and commercial glazes to choose from to achieve your desired results. *Cone 06 – Cone 8*

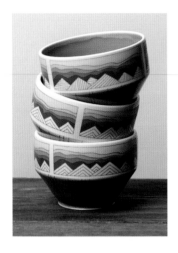

SODA – Not to be confused with salt firing, although the techniques are similar. The main difference is that a mixture of baking soda and soda ash are mixed with water and sprayed into the kiln near the maturing temperature. The sodium interacts with the silica and calcium carbonate in the glaze to form a layer of glass. Soda firing also requires a gas kiln specifically for this firing. *Cone 10*

Luke Doyle

REDUCTION – A firing technique that is achieved in a gas kiln. In reduction firing, the kiln is starved of oxygen, causing incomplete combustion. Carbon monoxide steals oxygen from the materials in the glaze, leading to certain glaze effects only achievable in a gas-reduced environment, such as *tenmoku* glaze and copper red glaze. *Cone 06 – Cone 10*

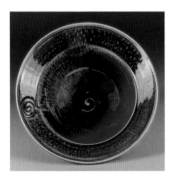

Gabriel Kline

WOOD – The oldest method of firing pottery in a large chamber kiln fueled only by wood. It was traditionally built into the landscape of a mountain but can be built of brick and freestanding. This type of firing takes several days and requires 24-hour stoking and monitoring–often a group effort. Wood when burned creates wood ash. At a very high temperature, this ash falls onto the surface of the pots, creating an often glossy, sometimes muddy layer of glaze. *Cone 10 – 13*

SALT – Salt firing is an atmospheric firing wherein salt (sodium chloride) is introduced in the kiln near the end of the firing cycle at a very hot temperature. The salt vaporizes and is carried by the flame throughout the kiln and onto the pots, combining with the silica on the surface to form a hard glass glaze. Salt-fired pots are often recognizable with an orange peel texture. This method of firing requires a gas kiln built specifically for this purpose, as the salt coats the brick walls of the kiln. *Cone 10*

LOADING AND FIRING A GLAZE KILN

In a community clay setting, the staff will most likely load and fire your work. However, if pottery is a hobby you intend to maintain, knowing a little more will be beneficial. Whether you are transporting your pots to a studio to fire or working in a home studio, electric kilns are the most accessible and affordable. Here, I will focus on loading and firing.

Loading

Loading a glaze kiln is very similar to loading a bisque kiln, but different in one key way: pots in a glaze kiln cannot be touching. This means that no glazed pots should touch on their sides, no stacking of pots, and no glazed surfaces touching the kiln shelves. This is because if pots are touching, they will likely be stuck together for life. To ensure this doesn't happen, leave a finger-width between each pot, because as the glaze is close to reaching temperature, it can bubble slightly.

While loading, it is also a good idea to check all the bottoms of the pots to be sure there is no glaze left on the surface or too close to the foot.

Another tip for success in glaze firing is to stagger your kiln shelf layers. Rather than having four posts, try using three posts per shelf at varying heights per layer. This will ensure even flow of the heat throughout the kiln. This is not absolutely necessary, but many potters prefer this method of loading, especially in gas kilns when atmosphere comes into play.

Programming the Kiln

With your glaze kiln completely loaded, lid closed, and the peepholes closed, program your kiln. Always read the manual first because each kiln brand varies in function and program. Most potters prefer to use the easy cone-fire method in which you plug in your desired temperature and speed. Other potters prefer to use the ramp/hold option to plug in their own specific firing schedule.

No matter the brand or the method, I recommend programming your kiln to fire at a medium speed for glaze firing. This is middle of the road. Some potters in a hurry will program their kiln to fire quickly, while others will fire their kiln slowly to allow for full development of the glaze. If you're not sure where you stand, try all three and take notes. Below is an example of a typical glaze firing schedule at medium speed.

Cone 6 in an Electric Kiln Medium Firing

Below is an example of the factory installed multisegment program when you press cone 6 medium speed on a skutt kiln.

SEGS	RATE	TEMP
1	200°F (93°C) / Hr	180°F (82°C)
2	200°F (93°C) / Hr	250°F (121°C)
3	400°F (204°C) / Hr	1000°F (538°C)
4	180°F (82°C) / Hr	1150°F (621°C)
5	300°F (149°C) / Hr	1982°F (1083°C)
6	120°F (49°C) / Hr	2232°F (1222°C)

PREPPING A PIECE FOR GLAZE

Before you glaze, make sure your work is dust-free so the glaze will adhere to the pot. Once your pots are clean, you have the option to wax the bottoms so the glaze won't stick to the pot. To wax, all you need is a brush and patience. Just be careful: if you get wax where you don't want it, you will have to re-fire the piece in a bisque kiln or use a torch to melt off the wax.

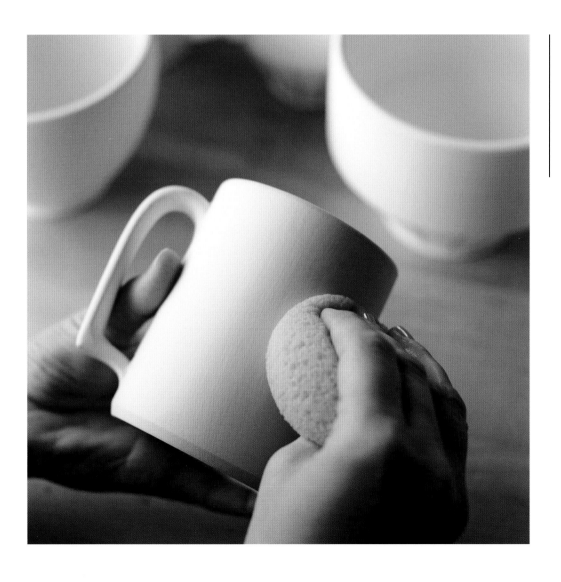

TOOLS AND MATERIALS

clean sponge

clean bucket of water

wax resist

paintbrush

bisqueware

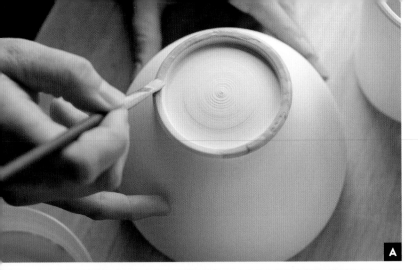

Wipe Clean

STEP 1 Wipe each pot inside and outside with a slightly damp sponge. If you use too much water, your pots might not have the time to properly dry before glazing. This might cause the glaze to look thin after firing. Your pot should dry almost as fast as you are wiping it.

TIP *Make sure your hands are clean! You don't want to eat a sandwich dripping in juices then handle your pots. Oil and grease, like dust, will prevent the glaze from sticking to the surface.*

Wax the Bottom

STEP 1 Using a paintbrush, cover the bottom of your pot with wax resist, including the foot and any part of the pot that will touch the kiln shelf. **[A]** If you're unsure of the glazes you are using, leave some extra space.

TIP *If you are having difficulty seeing the wax while painting, simply add a little bit of food coloring to the wax. This will not harm the wax or affect the pot; the wax will simply burn out in the firing.* **[B] [C]**

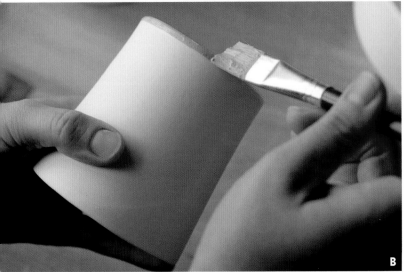

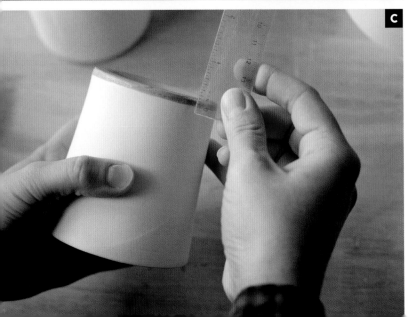

DIPPING A POT IN GLAZE

Dipping pots in glaze is the most common way to glaze a piece. Generally speaking, it is the easiest and fastest way to ensure an even and fluid application, compared to painting glaze, in which case some areas make be thicker and some thinner. To dip pots, we will use glaze tongs, but you can also use your hands if your pot has a foot that is substantial enough to hold onto.

TOOLS AND MATERIALS

bisqueware
glaze
glaze tongs
power mixer or stir stick
sponge

Instructions

STEP 1 Before beginning to glaze, thoroughly mix your glaze. I recommend using a power mixer, as this is the most precise way to ensure the glaze is mixed properly. You can also use a stick or a spatula. Whichever method you use, don't leave any glaze left unmixed at the bottom of the bucket. **[A]**

STEP 2 Open up the glaze tongs and gently clamp your pot. Depending on the wall thickness, if you clench your hands too tightly, you could puncture the pot. But if you don't hold the tongs tight enough, you might drop your pot in the glaze. Just like in pulling the walls of clay, you will eventually learn to use the right amount of pressure. **[B]**

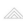

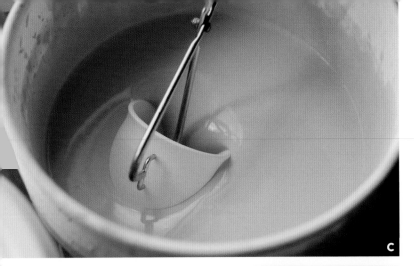

STEP 3 Dip your pot into the glaze with a fluid motion and for no longer than a few seconds. Count 1-2-3 and then pull it out. **[C]**

STEP 4 When you pull your pot out of the glaze, gently shake off excess glaze and allow it a few moments to dry before unclamping and setting down.

STEP 5 Once your pot is completely dry, gently rub any marks left by the tongs. If these markings seem excessive, dab glaze on them with a paintbrush to cover them up. **[D]**

STEP 6 Using a clean sponge, wipe off any glaze remaining on the bottom of your pot. Your pot is ready to be glaze fired. **[E]**

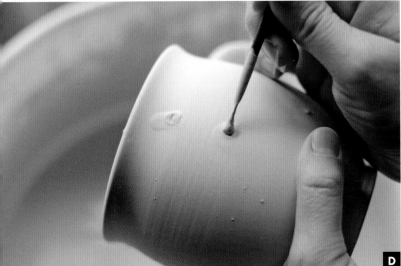

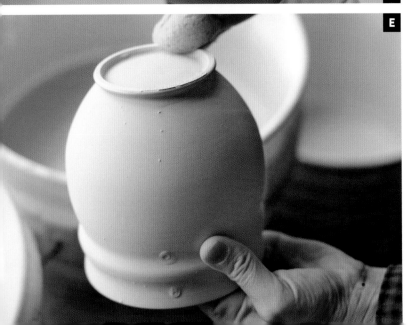

POURING AND DIPPING TO GLAZE A POT WITH TWO COLORS

Pouring is a great technique for glazing the inside of pots a different color than the outside. This is often called the "liner glaze." Pouring can also be useful for pots that are too large to fit in the glaze bucket. To successfully pour a glaze, I recommend using a lightweight plastic pitcher. Remember to thoroughly mix the glaze before pouring, even if you recently dipped a pot into the glaze, as glaze tends to settle fast.

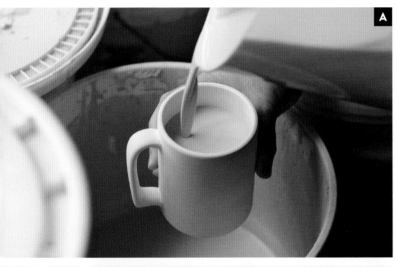

TOOLS AND MATERIALS

bisqueware

glaze

stir stick

pitcher

sponge

Instructions

STEP 1 Fill your pitcher with glaze. Holding your pot over the glaze bucket, pour the glaze to just below the rim. If you pour right up to the rim, it might be more difficult to pour the glaze back out and might run down the sides. **[A]**

STEP 2 Give the pot a swirl and dump the glaze back into the bucket. This should be a quick process. Don't allow the glaze to sit inside the pot for too long or the glaze will accumulate. Glazes that are too thick may not fire properly. **[B] [C]**

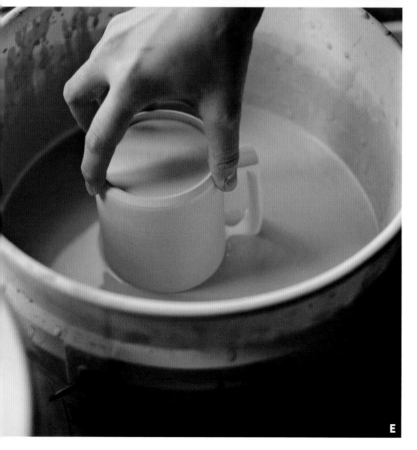

STEP 3 This step is optional. If you enjoy glaze drips on the rim and down the side of your pot, leave them. If you enjoy crisp lines, like me, wipe the drips and rim clean. **[D]**

STEP 4 Glaze the outside of your pot. Unless your pot is very large, I recommend using the dipping technique. If your foot is substantial enough to hold onto, dip it fluidly in one motion upside down. If not, glaze it in two moves.

STEP 5 Grab your pot by the rim and dip three-fourths of your pot into the glaze. Pull your pot out and shake off excess glaze. Let this dry to the touch before glazing the rim.

STEP 6 Now that the glaze has dried, grab your pot by the foot and dip it upside down into the glaze bucket again. I give my pot a little swirl so the inside gets layered with the second glaze. **[E]** Pull your pot out and shake off the excess glaze. You have successfully glazed a pot with two colors. Don't forget to wipe the bottom free of glaze before firing.

Layering Glazes

Layering glazes is an obsession for some potters. The unique colors and combinations can lead to fiery and luscious glazed surfaces. It is a good idea to start small by layering just two glazes per pot and testing different combinations. This way you will get a feel for how much the glaze will "move" during the firing without accidentally attaching your pot to the kiln shelf. Double the glaze means double the volume and the likelihood that the glaze will run down the pot during firing. Before adding a second glaze, it is important that the first glaze is completely dry to the touch. A common misstep is grabbing onto your pot too soon, causing the glaze to stick to your fingers and lift off the pot.

It is best to layer glazes at the top of the pot rather than the bottom, as this gives the glaze more room to run. To do this, take a pot you have glazed with a single color and dip your pot upside down in the second color of your choosing. **[A] [B]** To start, I suggest covering only about one-fourth of the pot with the second glaze. Better to be safe than sorry.

After your glaze has dried completely, wipe off the bottom. Your pot is ready for firing.

Common glaze mistakes when layering:

- Layering too many glazes, causing the layers to start chipping off.
- Rushing and not mixing the layering glaze properly, which can cause the glaze application to be chunky.
- Not allowing the glaze to dry completely before touching your pot, causing smudges.

If you made a mistake, don't worry. Rinse the glaze off before firing and start over. To wash your glaze off, use running water and a sponge. When all of the glaze is removed, it is very important to let your pot dry completely before glazing again. This could take several days in a humid climate. You can also re-bisque the piece if you want to be completely certain all the moisture is out.

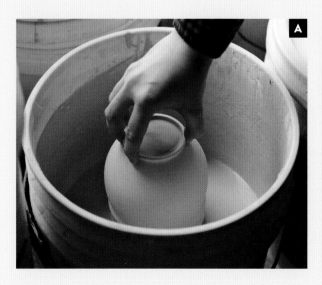

OVERGLAZE: DECALS

If you thought that glazing was the last step in making pottery, think again. Overglaze surface decoration has been around for many years and includes a variety of techniques, including china painting, decaling, and luster firing. Of course, I can't write a pottery book without talking about my favorite part of the process: decaling. Decals are different from transfers (see page 103) as they are applied over the glaze rather than under it. They require a special kind of paper called waterslide decal paper.

In college I screen printed my own decals using china paints and a decal medium. The downside to this process is that it requires toxic materials to turn the china paint into a screen-printable medium, including harsh solvents to then clean the screen. Also, using this method I was limited to printing one color at a time. Talk about time-consuming! This was about the time I started researching decal printers. I discovered there were two main ways to print decals: using a standard laser jet printer and using a specialty china paint printer.

Laser jet printers often contain red iron oxide in the ink. Red iron oxide is a common colorant used in clay and glaze recipes. It fires to a rich sepia tone. Laser jet printers are very popular in the decal world because they are affordable and easily accessible. The limitation is the color. Only the black ink contains red iron oxide, so you are limited to hues of sepia tone. These printers require waterslide decal paper specifically designed to harden the image so when you submerge the decal in water for application, it doesn't dissolve. The thin membrane then lifts the image off the paper.

Color decal printers can print in either CMYK or RGB format. They are graphic design printers that use china paint as toner instead of ink. In these special printers, the toner mixes with a powdered medium to print full color images on decal paper. They are gaining popularity in the ceramic world as technology advances but are still unattainable for many due to their high price. Don't let this stop you, though. Several companies sell stock image decals and will even custom print your designs for you.

DESIGNING A DECAL

When it comes to designing decals, I recommend waiting until your piece has been glaze fired. You could plan and sketch ahead of time, but if you want your decal to be the correct size, it's best to wait and measure instead of guessing about shrinkage. There are several ways to design and make decals. I will share the process that has worked the best for me. Because every computer and design program is slightly different, I won't discuss the computer aspect of designing decals, but I hope my drawing and planning stages give you the tools you need to carry on.

TOOLS AND MATERIALS

paper
glazed pot
pencil
micron pen
transparency paper
scissors
scanner
computer
design program

131

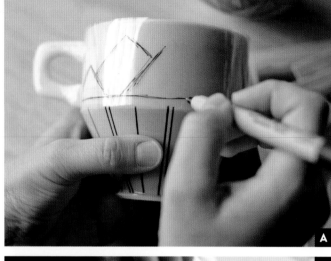

A

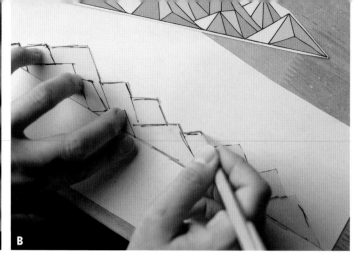

B

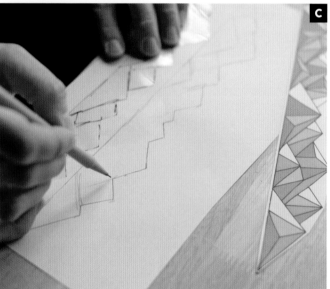

C

Instructions

STEP 1 Hold your transparency paper up to the desired decal area and trace the margins. **[A]**

STEP 2 Cut out the transparency and trace it on to blank paper. **[B]**

STEP 3 Sketch your design with a pencil first. **[C]**

STEP 4 Once you are happy with your design, go over the lines with a micron pen. Once the pen ink is dry, erase all remaining pencil marks. **[D]**

STEP 5 Scan your image and work with it in your design program. When done with your image, create a print sheet. This will depend largely on where and how you intend to print your decals. Most companies have their own format stipulations for size and color profile, so it is a good idea to be aware of this before you get carried away.

TIP *Custom-printed decals are not cheap. Therefore, I recommend filling your print page to the margins. Allow enough space to cut out your image, but fill that page up.*

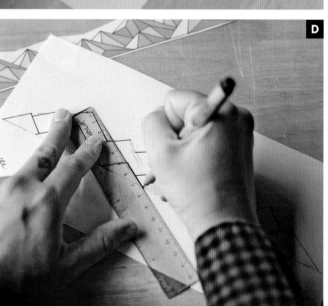

D

APPLYING AND FIRING DECALS

With your decals printed, start the application process. This is by far the most satisfying aspect of working with decals. It's the moment you see your pot transform into something else entirely.

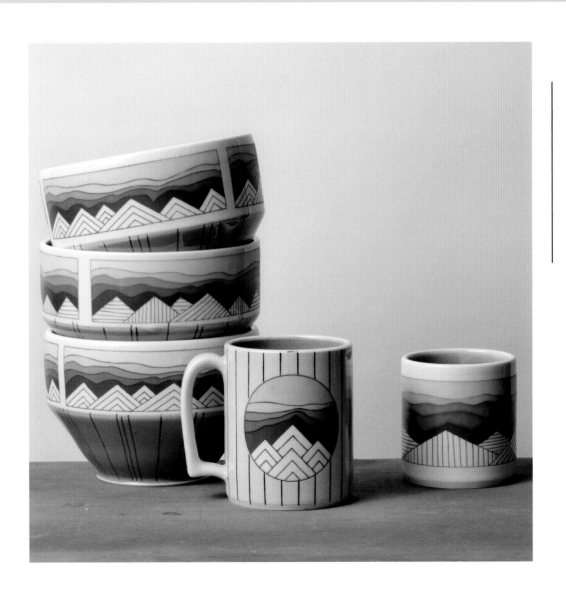

TOOLS AND MATERIALS

paper towels
sponge
rubbing alcohol
decal
scissors
bowl of clean warm water
glazed pot

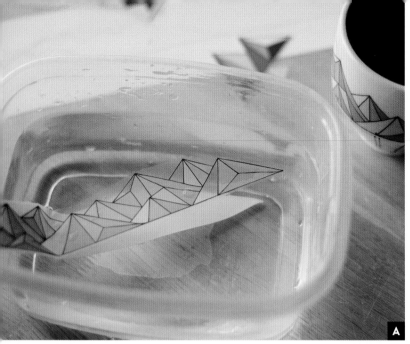

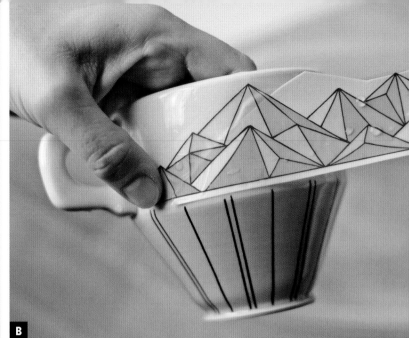

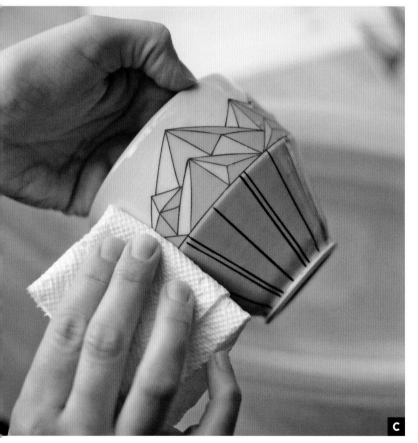

Applying Decals

STEP 1 Before diving in, I recommend cleaning the surface of your pot with rubbing alcohol. This is an important step to ensure there is no dirt or dust that would hinder the glaze when re-fired to decal temperature. Dip a rag or paper towel in rubbing alcohol and wipe it down. You want the towel to be slightly dampened but not soaking wet.

STEP 2 Now that your pots are clean, cut out your decal using scissors or an X-ACTO knife. Submerge your decal in warm water, which adds a little stretch.

STEP 3 The decal may take anywhere from 15 to 60 seconds to lift off the paper depending on how warm your water is. When the decal starts to lift away from the paper, remove it from the water but keep it on the backing. This will add extra support to your decal, easing the transition from the water dish to the pot. **[A]**

STEP 4 Slide the decal off the backing and onto your pot. **[B]**

STEP 5 Gently remove excess water from under the decal by starting in the middle and working your way out. Use one hand to hold the decal in place while the other slides across the decal with a paper towel or sponge to absorb the water. **[C]** After all of the water has been properly removed, your pot can be fired now, but I recommend letting the decals sit overnight or at least a few hours to ensure they are completely dry.

Firing Decals

It is time to fire again. Decals have to be fired into the surface of the glaze to make them functional and durable. This requires a lower temperature than the bisque firing because you don't want to completely re-melt your glaze. You want to soften it just enough so the decal sinks into the glaze. Most decal companies will give you a program or a specific cone to fire to, so follow the instructions. I also recommend test firing a few pieces first, as every kiln fires differently. Generally speaking, laser jet decals fire between cone 08 and cone 04, while china paint decals fire from cone 018 to cone 014.

Troubleshooting

- ▸ Why do my decals look dry and can be scratched off? Try firing hotter. Did you use a witness cone? The best way to see whether your kiln is firing accurately to temperature is by placing a witness cone near your pieces. Sometimes it is a fine line of just a few degrees that can make all the difference.
- ▸ Why are there tiny bubbles on the surface of my pots after decal firing, and some are popped and sharp? Your kiln got too hot. Try firing at a slightly lower temperature. What happens in a decal firing is that the glaze starts to melt, allowing the decal to seal into the surface. If you fire a bit too hot, the glaze will bubble because it doesn't have enough time to flux out again like in the glaze firing. Don't fret, this is why it is a good idea to test.
- ▸ Why are there small circles where the decal didn't adhere properly to the pot, revealing the glaze underneath? This is caused by air bubbles or water pockets left under the glaze. Be sure that all moisture has been taken out from under the decal.
- ▸ Can I use images from the internet? This is a tricky topic. Generally no, you can't just grab an image off the internet and use it as your own. Because most images are copyrighted, you should either pay for the use of that image or use a non-copyrighted image. It is okay to gain inspiration from designs that are already out there, but they cannot be identical. Imagine if someone used your design and sold it as their own without giving you credit. In the art world, we all need to look out for each other.

Meredith Host, Dot Floral Dessert Plate

Liana Agnew, Plate

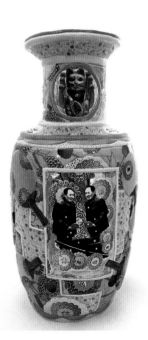

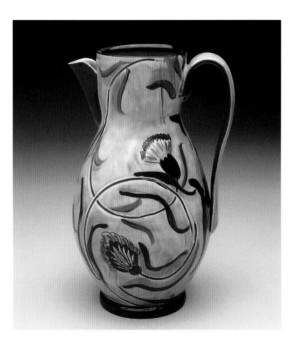

Mariko Paterson, Xi Jinping Vase

Ben Carter, Blue Swirl Pitcher Wheel-thrown and decorated with slip, underglaze, sgraffito and glaze before being fired to cone 4 in an electric kiln

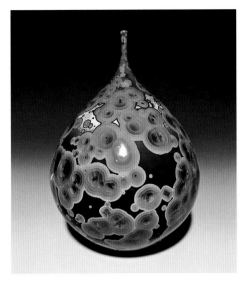

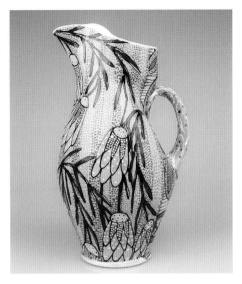

Ian Childers, Blue Crystalline Vessel Porcelain

Matthew Schiemann

*Crystalline glazes require complex firing schedules
where the temperature is held at specific intervals
during the cooling process.*

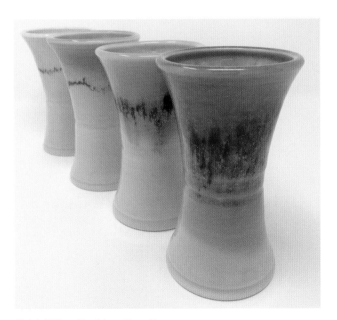

Gabriel Kline, Tumblers Cone 7

Gabriel uses a variety of methods to glaze but specializes in layering glazes.

CONTRIBUTING ARTISTS

Agnew, Liana
www.lianaagnew.com

Allen, Jen
www.jenniferallenceramics.com

Arnold, Mark
www.markarnoldceramics.com

Ballek, Sara
www.saraballek.com

Bartels, Anja
www.anjabartelsporcelain.com

Caffery, Laurie
www.lauriecaffery.com

Carter, Ben
www.carterpottery.com

Childers, Ian
www.ianchilders.com

Cinelli, Mike
www.artaxis.org/artist/mike-cinelli

Donner, Rachel
www.racheladonner.com

Doty, Gillian
www.gillandoty.com

Doyle, Luke
www.lukedoylepottery.weebly.com

Gisondo, Paul
www.odysseyclayworks.com

Eliades, Adriene
www.adrienneeliades.com

Heerspink, Eric
www.ericheerspinkceramics.com

Host, Meredith
www.meredithhost.com

Kline, Gabriel
www.ceramicartsnetwork.org/
author/gabriel-kline

Levin, Simon
www.simonlevin.com

LoPresti, Renee
www.reneelopresticeramics.com

Paterson, Mariko
www.foragestudios.com

Riddle, Austin
www.austinriddlepottery.com

Schiemann, Matthew
www.schiemannceramics.com

Schwartzkopf, Deb
www.ratcitystudios.com

Spontak, Heather
www.heatherspontak.com

Tovey, Shannon
www.shannontovey.com

RESOURCES

Art Centers

Archie Bray Foundation for the
Ceramic Arts
Helena, MT
www.archiebray.org

Armory Art Center
West Palm Beach, FL
www.armoryart.org

Baltimore Clayworks
Baltimore, MD
www.baltimoreclayworks.org

Burnish Clay Studio
Bellingham, Washington
www.burnishclaystudio.com

Carbondale Clay Center
Carbondale, CO
www.carbondaleclay.org

Clay Art Center
Port Chester, NY
www.clayartcenter.org

Clay Arts Vegas
Las Vegas, NV
www.clayartsvegas.com

The Clay Studio
Philadelphia, PA
www.theclaystudio.org

The Clay Studio of Missoula
Missoula, MT
www.theclaystudioofmissoula.org

Greenwich House Pottery
New York, NY
www.greenwichhouse.org/pottery

Harvard Ceramics
Allston, MA
www.ofa.fas.harvard.edu

Morean Center for Clay
St. Petersburg, FL
www.moreanartscenter.org

Mudflat Studio
Cambridge, MA
www.mudflat.org

Northern Clay Center
Minneapolis, MN
www.northernclaycenter.org

Odyssey Center for Ceramic Arts
Asheville, NC
www.odysseyceramicarts.com

Pewabic Pottery
Detroit, MI
www.pewabic.org

Pottery Northwest
Seattle, WA
www.potterynorthwest.org

Red Lodge Clay Center
Red Lodge, MT
www.redlodgeclaycenter.com

Santa Fe Clay
Santa Fe, NM
www.santafeclay.com

Seward Park Clay Studio
Seattle, Washington
www.sewardparkart.org

Watershed Center for the
Ceramic Arts
Newcastle, ME
www.watershedceramics.org

Wayne Art Center
Wayne, PA
www.wayneart.org

Worcester Center for Crafts
Worcester, MA
www.worcestercraftcenter.org

Publications and Artist Resources

Ceramics: Art and Perception|
Technical
www.mansfieldceramics.com/
product-category/magazine

Field Guide for Ceramic Artisans
www.ceramicsfieldguide.org

Ceramic Arts Daily
www.ceramicartsdaily.org

Ceramics Monthly
www.ceramicartsdaily.org/ceramics-
monthly

Ceramic Review
www.ceramicreview.com

CFile
www.cfileonline.org

Clay Times
www.claytimes.com

The Journal of Australian Ceramics
www.australianceramics.com/journal

New Ceramics
www.new-ceramics.com

Pottery Making Illustrated
www.ceramicartsdaily.org/
pottery-making-illustrated

Studio Potter Journal
www.thestudiopotterjournal.
tumblr.com

Finding a Studio

Apprenticelines
www.apprenticelines.org

Alliance of Artists Communities
www.artistcommunities.org/artists

Res Artis
www.resartis.org/en

Residency Unlimited
www.residencyunlimited.org

TransArtists
www.transartists.org

Ceramics Monthly residency issue
www.ceramicartsnetwork.org/
ceramics-monthly/ceramic-
art-and-artists/ceramic-artists/
residencies-and-fellowships-2015/

Health in the Studio

CERF: Craft Emergency Relief
Fund Studio Protector Small
Business Green Task Force
www.blog.nceca.net/category/
green-task-force

King County Hazardous Waste Help
www.hazwastehelp.org/ArtHazards/
ceramics.aspx

Digital Fire
www.digitalfire.com/4sight/hazards/
ceramic_hazard_dealing_with_dust_
in_ceramics_372.html

Kristen Keiffer's Standing and
Throwing Blog
www.kiefferceramics.com/2018/01/
01/psa-standing-ergonomics/

Favorite Tools

Mudtools
www.mudtools.com

Studio Pro Bats
www.studioprobats.com/

Brent Wheel Extensions
www.amaco.com/products/
leg-extension-kit-new

Shimpo Banding Wheel
www1.ceramics.nidec-shimpo.com/
banding-wheels

GR Pottery Forms
www.grpotteryforms.com/

MKM Pottery Tools
Decorating Disc
www.mkmpotterytools.com/

CircleMatic Template System
Sandi Pierantozzi
www.circlematic.com/

Pure & Simple Pottery Products
Plaster mold making
www.pureandsimplepottery.com

Ceramics Equipment and Materials Suppliers

Aardvark Clay
Santa Ana, CA
www.aardvarkclay.com

American Art and Clay Company
Indianapolis, IN
www.amaco.com

Archie Bray Clay Business
Helena, MT
www.archiebrayclay.com

Axner Pottery and Ceramic Supplies
Oviedo, FL
www.axner.com

Bailey Ceramic Supply
Kingston, NY
www.baileypottery.com

Big Ceramic Store
Sparks, NV
www.bigceramicstore.com

Blue Bird Manufacturing
Fort Collins, CO
www.bluebird-mfg.com

The Ceramic Shop
Philadelphia PA
www.theceramicshop.com

Clay Art Supply
Tacoma, Washington
www.clayartcenter.net/

Clay King
Spartanburg, SC
www.clay-king.com

Clay Planet
Santa Clara, CA
www.clay-planet.com

Continental Clay Company
Denver, CO, and Minneapolis, MN
www.continentalclay.com

Crane Yard Clay
Kansas City, MO
www.kcclay.com

Georgie's Ceramic and Clay Co.
Portland, Oregon
www.georgies.com/

Highwater Clays
Asheville, NC
www.highwaterclays.com

Laguna Clay
City of Industry, CA
www.lagunaclay.com

L&L Kiln Manufacturing
Swedesboro, NJ
www.hotkilns.com

Mid-South Ceramic Supply Co.
Nashville, TN
www.midsouthceramics.com

New Mexico Clay
Albuquerque, NM
www.nmclay.com

Peter Pugger Mfg.
Ukiah, CA
www.peterpugger.com

Seattle Pottery Supply
Seattle, WA
www.seattlepotterysupply.com/

Sheffield Pottery
Sheffield, MA
www.sheffield-pottery.com

Shimpo
www.shimpoceramics.com

Skutt Kilns
www.skutt.com

Soldner Clay Mixers by Muddy Elbow Mfg.
Newton, KS
www.soldnerequipment.com

Standard Ceramic Supply Company
Pittsburgh, PA
www.standardceramic.com

Venco
www.venco.com.au

Recommended Reading

Ceramics, Philip Rawson and Wayne Higby

The Complete Guide to High-Fire Glazes: Glazing & Firing at Cone 10, John Britt

The Complete Guide to Mid-Range Glazes: Glazing & Firing at Cones 4–7, John Britt

The Craft and Art of Clay, Susan Peterson

Cushing Handbook, Val Cushing

Electric Kiln Ceramics: A Guide to Clays, Glazes, and Electric Kilns, Richard Zakin and Frederick Bartolovic

Functional Pottery: Form and Aesthetic in Pots of Purpose, Robin Hopper

Glaze: The Ultimate Ceramic Artist's Guide to Color and Glaze, Brian Taylor and Kate Doody

Graphic Clay: Ceramic Surfaces and Printed Image Transfer Techniques, Jason Bige Burnett

Mastering Cone 6 Glazes: Improving Durability, Fit and Aesthetics, John Hesselberth and Ron Roy

A Potter's Workbook, Clary Illian

Ten Thousand Years of Pottery, Emmanuel Cooper

Online Databases, Artist Collectives, and Member Organizations

Access Ceramics
www.accessceramics.org

Arbuckle Ceramics
www.lindaarbuckle.com/
arbuckle_handouts.html

Art Axis
www.artaxis.org

Ceramic Arts Network
www.ceramicartsnetwork.org

Digital Fire
www.digitalfire.com/index.php

Glazy
www.glazy.org

Kamm Teapot Foundation
www.kammteapotfoundation.org

National Council on Education for the Ceramics Arts
www.nceca.net

Objective Clay
www.objectiveclay.com

The Potter's Council
www.ceramicartsdaily.org/
potters-council

The Rosenfield Collection
www.rosenfieldcollection.com

ABOUT THE AUTHOR

JULIA CLAIRE WEBER is a full-time studio artist (Julia Claire Clay) and a part-time gallery manager. A recent alumnus of the Odyssey Clayworks residency program, Julia was previously studio manager of Clayspace in Erie and is a graduate of the Edinboro University of Pennsylvania ceramics program. Julia keeps a full teaching schedule at craft and art centers across the country and her work has been widely featured and displayed, including exhibitions at NCECA, Pottery Northwest, Houston Center for Contemporary Craft, Objective Clay, and the Touch-stone Center for Crafts. In print, Julia's work can be seen in *Amazing Glaze, Creative Pottery, Ceramics Monthly, Ceramic Arts Daily,* and more.

ACKNOWLEDGMENTS

First, I would like to thank my parents, who have always encouraged me to follow my dreams. They taught me that hard work, passion, and perseverance are the key ingredients to turning a talent into a career. I wasn't sure how they would react when I switched my major from art education to clay, but when I called home to say, "I know what I want to do with the rest of my life: CERAMICS!" they were incredibly supportive. Which was amazing, considering I was making lumpy pots at the time! Nonetheless, they proudly displayed my paperweights in their home, drove me to my first NCECA because I was nervous, and attended every show opening thereafter. Mom and Dad, thank you for believing in me.

To my professors, especially Lee Rexrode, thank you for recognizing that spark within me and nurturing my passion for ceramics. To Linda Cordell, for pushing me to explore surface and move beyond the barriers of my comfort zone. To the graduate students who so kindly took the time to answer my many questions and guide me through my first ever firings, namely Jason Stockman, who never asked me to put a quarter in his questions jar, even though I picked his brain daily!

To Kristen Muscaro-Winters and Travis Winters, who encouraged me to become a short-term resident at Odyssey Clayworks. My life blossomed because of their unwavering support. Special thanks to Gabriel Kline, the director of Odyssey Clayworks, who believed in me enough to hold a long-term residency position and has been nothing short of an exceptional "boss," mentor, and friend. It's not an exaggeration to say the residency changed me exponentially as an artist, an educator, and a person. Also to the staff and students of Odyssey, who so patiently allowed for the shooting of this book to happen without complaining that the lights were out and instead offered their excitement and encouragement!

To Kristen Keiffer, Deb Schwartzkopf, and Jason Burnett, for allowing me to assist their workshops, opening me up to a new level of growth and connection within the clay community. For these experiences I extend my deepest gratitude. Also to the contributing artists, thank you, thank you! Your work inspires me, and I am honored and humbled to include you in this book. Special thanks to Mark Arnold for being a super pal and for writing the forward—I can't thank him enough.

To my countless students over the years, thank you for allowing me to teach you. I am inspired by your perseverance and willingness to jump right in. The laughter, conversations, and explorations have enriched my life.

To Jack Sorokin, the incredibly talented and humble photographer who shot the photos for this book. Jack is nothing short of a rock star. He captured the essence of this book perfectly and brought a level of patience unmatched by many. I am so grateful for his flexibility and for showing up at my house to shoot the kiln-loading section as I last-minute panicked packing green pots to transport to Odyssey!

Special thanks to the team at Quarto Publishing, especially Thom OHearn, the exceptional editor who believed in me. This book would not be possible without his guidance, encouragement, and gentle patience as I found a way to milk each deadline.

Lastly, I would like to thank my partner, Micah Yaple, who never stopped believing in me despite my best efforts to drive him absolutely bonkers! He remained patient and vigilant in his encouragement. Thanks for dealing with my handwritten chapters all over the house, the late nights, and coming home from work early to help recover the files I lost. I love you, and I am so grateful for your unconditional support!

INDEX